How to Draw t
HUMAN
FIGURE

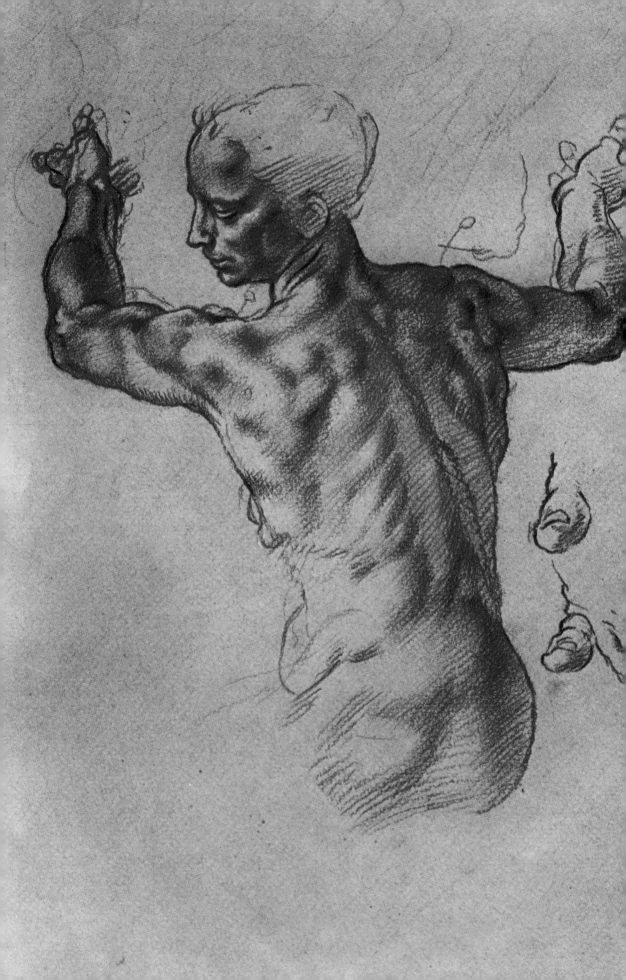

How to Draw the
HUMAN
FIGURE

José M. Parramón

Watson Guptill Publications/New York

Copyright © by José M. Parramón Vilasaló
Copyright © 1989 by Parramón Ediciones, S. A.

First published in 1990 in the United States by Watson-Guptill
Publications, a division of BPI Communications, Inc.,
770 Brodway, New York, NY 10003-9595, USA

Library of Congress Catalog Card Number: 89-48711

Parramón, José María.
 [Cómo dibujar la figura humana. English]
 How to draw the human figure / José M. Parramón.
 p. cm.—(Watson-Guptill artist's library)
 Translation of: Cómo dibujar la figura humana.
 ISBN: 0-8230-2358-3
 1. Anatomy, Artistic. 2. Human figure in art. 3. Drawing—Technique.
I. Title. II. Series.
NC760. P3313 1990
743'.4—dc20—dc20
 89-48711
 CIP

Manufactured in Spain

8 9 / 03 02 01 00

Contents

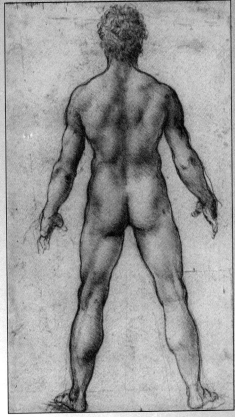

2

Fig. 1. (Page 2) Copy of a sanguine study of *The Creation of Adam* by Michelangelo for the mural painting of the Sistine Chapel in the Vatican, Rome.

Fig. 2. From a drawing by Leonardo da Vinci, *Figure Seen from Behind*. Royal Library, Windsor Castle, England.

Leonardo da Vinci, Dürer, Raphael, Botticelli, and many other artists of the Renaissance studied and drew the human body in ideal proportions. But the first artists to analyze this problem and establish some concrete norms and dimensions were those of ancient Greece: Myron, Parrasio, Zeuxis, and later Polyclitus, who even wrote a treatise on the rules of artistic harmony entitled *The Canon*. Since then, the canon has been understood as *the rule that establishes the ideal dimensions of the human figure.* In the following pages we will discuss this canon, which uses *modules,* or measurements of the proportions and dimensions of the human body of a man, woman, and child.

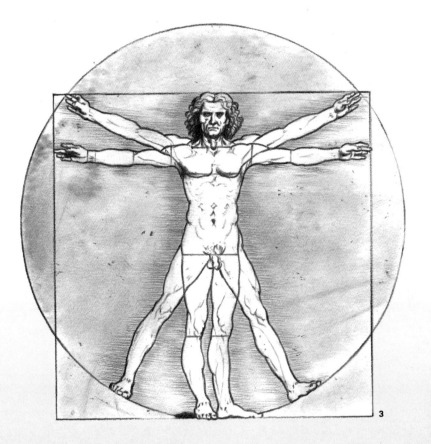

3

THE CANON
—OF THE—
HUMAN FIGURE

The study of proportions

Figs. 4 and 7. The *Doryphorus* is a work by the ancient Greek artist Polyclitus, who in his book, *The Canon*, established the ideal height of the human body as seven and a half heads. Sculptors during Polyclitus's epoch (5th century B.C.), among them Phidias, Parrasio, and Zeuxis, applied this canon in all their works.

Polyclitus, Praxiteles, and Leochares were three famous sculptors of ancient Greece. All three tried to solve a problem that was not finally solved until the beginning of the 20th century: *the problem of the ideal proportions of the human figure.*

Here is a summary of the story.

In the 5th century B.C.—some 2,500 years ago—Polyclitus wrote a treatise entitled *The Canon*, in which he established the following rule:

To achieve a perfectly proportioned body, the figure must measure seven and a half heads.

Practicing what he preached, Polyclitus applied this canon to all his sculptures (Fig. 7).

As you know, by "canon" we mean the rule or system by which the proportions of the human figure are determined and related to one another. This is based on a measurement called the "module." The module, used from

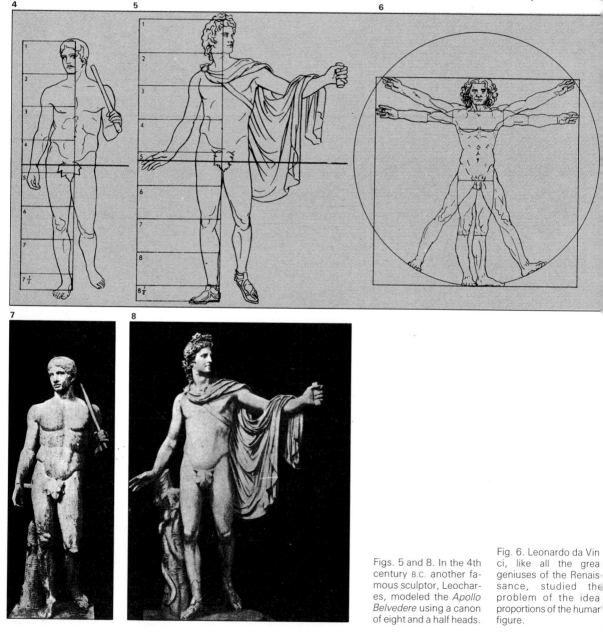

Figs. 5 and 8. In the 4th century B.C. another famous sculptor, Leochares, modeled the *Apollo Belvedere* using a canon of eight and a half heads.

Fig. 6. Leonardo da Vinci, like all the great geniuses of the Renaissance, studied the problem of the ideal proportions of the human figure.

the Renaissance to the present, is equal to the measurement of the head. Polyclitus's canon was unanimously accepted by all the artists of the age, including Phidias and Myron. It was a landmark in the history of Greek art, establishing the style and proportions of the so-called *Classical period*. From that moment on, it seemed probable that all artists—draftsmen, painters, and sculptors—would use the canon of seven and a half heads to represent the ideally proportioned human figure. But less than a hundred years later, a new genius, Praxiteles, established the eight-head canon. Almost simultaneously, another famous sculptor, Leochares, was creating the *Apollo Belvedere*, one of the most beautiful sculptures in the world, basing his proportions on a canon of eight and a half heads (Figs. 5 and 8).

Which of the three was right? Which canon should artists adopt in the future?

Clearly, painters and sculptors of the Renaissance—2,000 years after the time of Polyclitus—asked themselves the same questions. It is equally clear that they found no satisfactory answers to these questions.

"Seven and a half!" said Michelangelo, as he sculpted his famous *David*. "Eight!" argued Leonardo da Vinci, supporting his arguments with a canon he calculated himself. "Nine!" declared Botticelli, pointing to his *Saint Sebastian*.

In 1870, a Belgian anthropologist named Quételet made a comparative study of the measurements and proportions of several adults and obtained what he considered to be a satisfactory average. The results were a canon of seven and a half heads, an "ideal" figure whose proportions were very similar to those of Polyclitus's *Doryphorus*.

Finally, at the beginning of the 20th century, another scientist named Stratz argued that in order to represent the

ideal form, *it was necessary to base one's measurements on a group of preselected individuals.* According to this theory, Stratz selected a group of tall, athletic, well-proportioned individuals. He calculated their average measurements and obtained the true, ideal figure: a human being whose proportions correspond to the eight-head canon.

We might conclude from the work of Richer, Von Lange, and Stratz himself that the *Apollo Belvedere*, with its canon of eight and a half heads, was an exaggeration of the ideal. We might add that Leochares, sculptor of the *Apollo Belvedere*, probably adopted this canon, not by chance, but in the full knowledge of what he was doing. The statue's "wonderful unreality" was most appropriate for the figure of a god-like Apollo, who was, moreover, the god of the fine arts in ancient Greece.

The matter was settled.

Figs. 9 and 10. Michelangelo, *David*, Gallery of the Academy, Florence. Sandro Botticelli, *Saint Sebastian*. Staatliche Museen, Berlin (West). Michelangelo's *David*, with its seven and a half heads, corresponds to Polyclitus's canon, while Botticelli's *Saint Sebastian*, with nine heads, surpasses the proportions of the *Apollo* of Leochares.

9

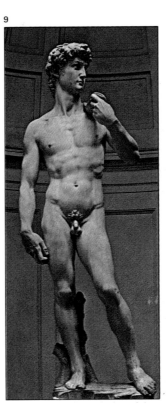

10

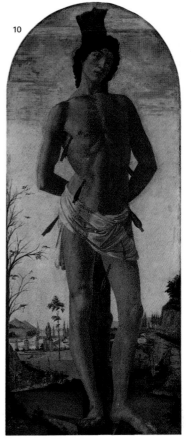

The three canons of the human figure

Thanks to our predecessors, and to all they did and said on the subject, we arrive at the following conclusions:

1. There are three canons for determining the proportions of the human figure:
 a) A canon of seven and a half heads for the ordinary figure (Fig. 12).
 b) A canon of eight heads for the ideal figure (Fig. 13).
 c) A canon of eight and a half heads for the heroic figure (Fig. 14).
2. The canon normally used by artists is the eight-head canon, which corresponds to the proportions of the ideal figure (Fig. 13).

Let us now consider the practical application of these conclusions:

The seven-and-a-half-head canon may be used for drawing ordinary figures taken from everyday life. It is the anonymous figure that represents the neighbor across the street or the man in the corner store—the man in the street. The shortish figure, about 5′ 6″ (1 m 65) or 5′ 8″ (1 m 70) tall, on the stout side, has rather a large head in proportion to the size of the body, the thighs, and the legs (Fig. 12).

The eight-and-a-half—head canon—or nine, if necessary—may be used for exceptional cases, for idealized and exaggerated legendary and heroic figures (Fig. 14). This is the figure normally used by comic strip illustrators; it has a small head in relation to its body and long legs. This is the heroic figure who goes by the name of Superman or Batman. It can also be used for the biblical Moses or the legendary Cid in religious and historical paintings.

Let us now study the ideal figure of eight heads (Fig. 13), using it as the basis for our knowledge of the proportions and dimensions of the human body. Pay great attention to the following since, along with our knowledge of human anatomy, it represents an extremely important step toward a perfect grasp of the technique of figure drawing.

Figs. 11 and 12. When we compare the size and proportions of the ordinary human body, that is, one that is not specially selected, we obtain an average canon of seven and a half heads. This is the normal figure's canon.

Fig. 13. By calculating the canon based on a specially selected group of individuals, we get an eight-head canon, which is considered to be the *ideal figure*.

Fig. 14. If you draw or paint an idealized, heroic, or legendary figure, remember the possibility of establishing its proportions and size using an eight-and-a-half—head canon, like the one illustrated in this figure.

11

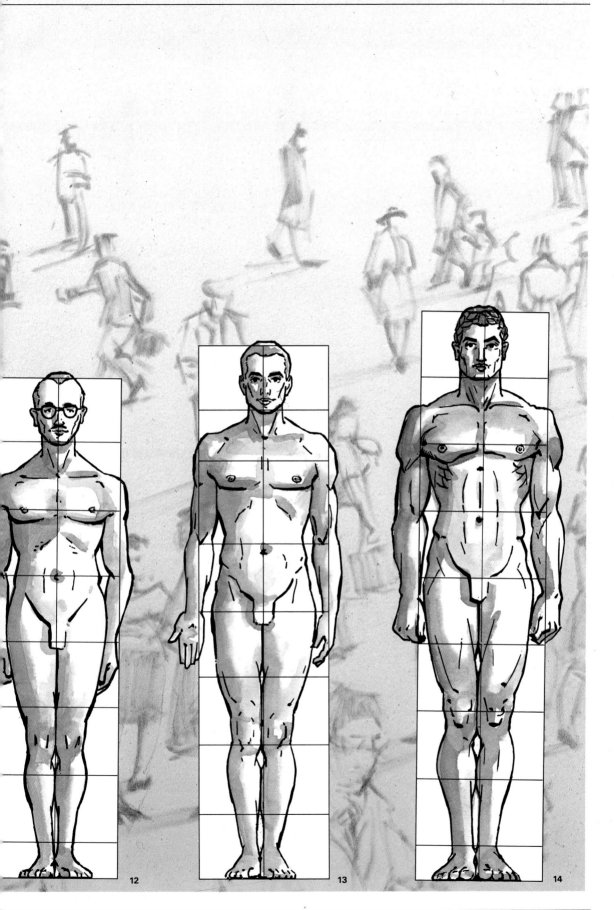

12

13

14

The ideal proportions of the human figure

The following figures (15, 16, 17) show the male figure standing at attention, seen from the front, the side, and the back, *proportioned according to the eight-head canon.*

First, note the overall proportions, comparing the height with the width, in Fig. 15, as seen from the front. You will see that it is

Eight heads high by two heads wide

By drawing a rectangle that measures eight units long by two units wide, we will have a "box" that will enclose an ideally proportioned human figure.

Now carefully study the following basic points, which are automatically determined by the dividing lines or modules of the canon. Notice that I have numbered the modules respectively, from 1 to 8, in order to identify more rapidly the following dimensions and positions.

a) The level of the shoulders coincides with subdivision A, which is situated a third of the way down module 2.

b) The nipples coincide exactly with the dividing line of module 2.

c) The navel is just below dividing line 3.

d) Both elbows are situated almost level with the waist, just above the navel.

e) The pubis is in the exact center of the body, coinciding with the dividing line of module 4.

f) The wrists are level with the pubis.

g) The extended hand is the same length as the face.

h) The total length of the arm from the top of the shoulder to the fingertips is equal to three and a half modules.

i) The most prominent part of the knee, the kneecap (see Fig. 16, the figure in profile), is just above module 6.

Also observe the following relationships, which are equally important for correctly representing and proportioning the male figure:

1. The space between the nipples is equal to one module (one head length).

2. By joining points B and C, we obtain:
 a) The position of the nipples.
 b) The position of the ends of the collarbone, or the most prominent part of the shoulder.

Finally, observe the male figure standing at attention in profile (Fig. 16). In that position, the calves project beyond the vertical line drawn from the shoulder blades to below the buttocks (points D, E, and F).

The points above are of the utmost importance. Study them closely and assimilate them, since they provide information that will be indispensable when you come to do your own male figure drawings.

Figs. 15, 16, and 17. *Eight heads high by two heads wide is the canon of the ideal figure.* Study the series of notes on the figures as seen from the front (15) and the profile (16) to check a number of relationships—such as the height of the face is the same as that of the hand, the nipples coincide with module 2, the pubis is in the center. This information will help you not only calculate the proportions and dimensions, but also construct the drawing in general.

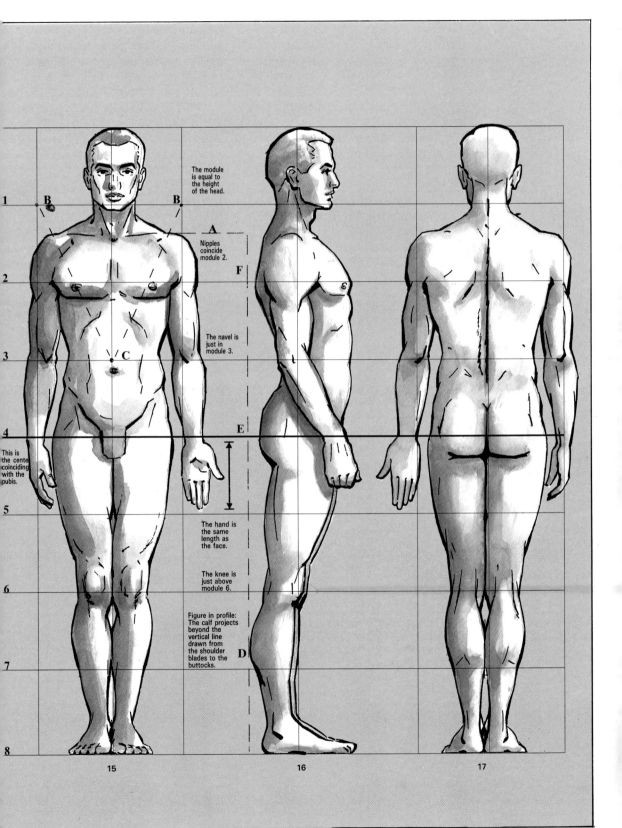

The module is equal to the height of the head.

A

Nipples coincide module 2.

The navel is just in module 3.

This is the center coinciding with the pubis.

The hand is the same length as the face.

The knee is just above module 6.

Figure in profile: The calf projects beyond the vertical line drawn from the shoulder blades to the buttocks.

15

16

17

Studies of the ideal proportions of the female figure

The eight-head canon also applies to the female figure, as you can see from Fig. 18. Since a woman's head is proportionally smaller than that of a man, the whole female body is shorter than the male's by approximately 4 in. (10 cm).

We should also stress the following differences between the male and the female figures, as shown in the illustration:

a) A woman's shoulders are proportionally narrower than a man's.
b) The breasts are lower, and the nipples are also slightly lower.
c) The waist is rather narrower than a man's.
d) The navel is slightly lower.
e) The hips are proportionally wider
f) Seen in profile, the buttocks protrude beyond the vertical line though they are generally aligned with the shoulder blade and the calf of the leg.

That is what the female figure is like—as long as fashion and other such factors do not dictate to the contrar (Figs. 19 to 22). One must take the following variables into account: In Germany during the Renaissance, for example, Dürer, Cranach, and Baldung were painting a stylized woman with a narrow chest and waist, while in Italy, or more precisely in Venice

18

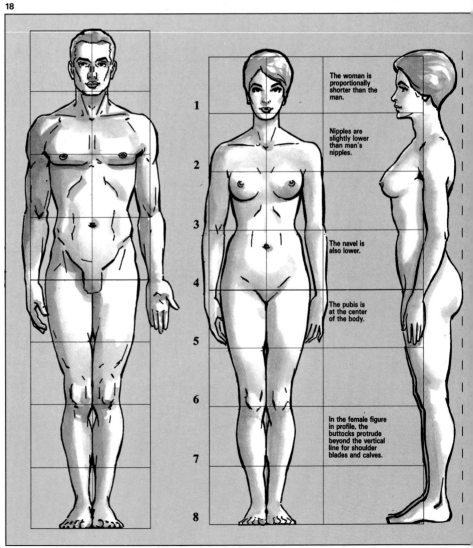

The woman is proportionally shorter than the man.

Nipples are slightly lower than man's nipples.

The navel is also lower.

The pubis is at the center of the body.

In the female figure in profile, the buttocks protrude beyond the vertical line for shoulder blades and calves.

1
2
3
4
5
6
7
8

Fig. 18. The canon of the female figure is practically the same except for one or two minor differences that must be taken into account, as you can see in this comparative illustration: For example, the head is proportionally smaller, the shoulders are slightly narrower, the hips are wider, the waist is narrower, and the body height is slightly smaller in general.

Figs. 19 to 22. Here we have some examples of the influence of fashion and customs on the woman's body. Note that during some periods thin bodies were represented, and in others more plump types predominated (from top to bottom): Hans Baldung, *The Three Graces*; Titian, *Venus Entertained by Music*; Peter Paul Rubens, *The Three Graces*, Prado Museum, Madrid; Badia Camps, *Nudes*, private collection.

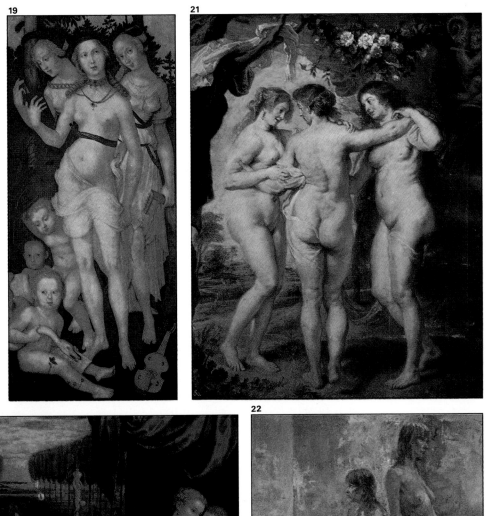

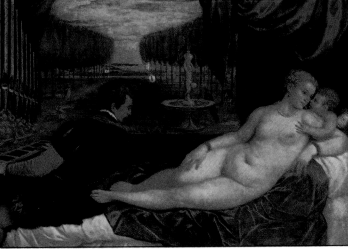

Giovanni Bellini, Titian, and Veronese were drawing and painting a robust woman's body with abundant flesh on the torso and thighs. One hundred years later, Rubens painted plump matrons as the ideal female figure; toward the end of the last century, fashion, dress, and the corset again promoted the thin waist, imposing bust, and abundant hips and buttocks. The woman of today is another type: She works, looks after her figure, and breaks records in the Olympic Games.

Childhood and adolescence

Fig. 23. A two-year-old, a six-year-old, and a twelve-year-old child have different proportions with canons of five, six, and seven modules.

Fig. 24. Mariano Fortuny (1838-1874), *The Flutist*. Fortuny Collection of the Royal Academy of Fine Arts of Sant Jordi, Barcelona. Drawing in charcoal.

Large headed, tubby, and short legged—that's what makes him so charming—the child is a true caricature of those ideal proportions studied by Polyclitus and others. There is no doubt that the child is quite different. Moreover, the child's shape is continually changing, from the time of birth until adulthood.

The reason for changes in the child's proportions is the premature development of vital parts of the body—the head especially—so that from the child's earliest years, they can fulfill the same or similar functions as in the adult.

Consequently, we have no alternative but to study and know several canons—at least, four—which reflect the salient characteristics of the newborn baby, the two-year-old, the six-year-old, and the twelve-year-old child. Refer to the adjoining graph (Fig. 23), and compare the above-mentioned canons with one another and with that of a twenty-five-year-old adult.

Study the following points and analyze the canon corresponding to each of the ages mentioned.

Canon of the newborn baby. Here the body equals four modules, with a head twice as big as an adult's in relation to the rest of the body. The proportions of the trunk and the arms are similar to those of the adult, while the legs are considerably shorter. We also know that the newborn baby has no waist as such, a narrow chest, rounded belly, fat, chubby arms and legs, and obvious folds at the joints; there is no suggestion of underlying muscle formations.

Canon of the two-year-old child. The shape of a two-year-old child is practically the same as that of the baby. The size of the head is still large in relation to the body. Although the child now has a thick head of hair, brighter eyes, and a fuller face, the legs are still short. However, the thorax is beginning to develop and increase slightly in

23

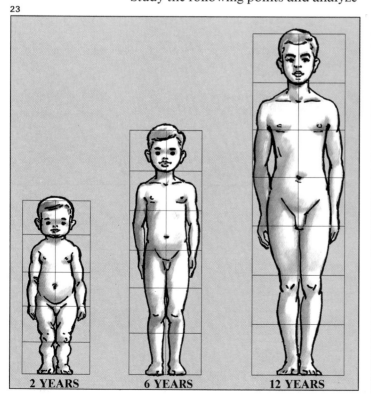

2 YEARS **6 YEARS** **12 YEARS**

24

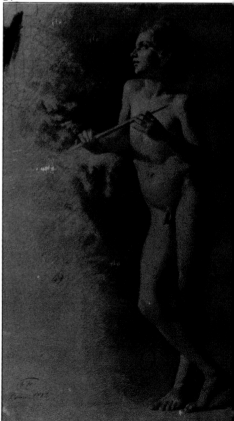

of the body. Although the plumpness has disappeared, the muscles are still not clearly defined, and as a result even the male body has a slightly feminine appearance.

Figs. 25 to 27. Canon of a two-year-old child, representative of the figure used by Rubens (Fig. 26) in *Seven Little Children with a Fruit Garland*, Alte Pinakothek, Monaco. Granted by Frans Snijders. Fig. 27. Detail of *The Immaculate Conception* by Murillo, Prado Museum.

elation to the hips and the buttocks, lthough the latter—like the belly— ontinue to be disproportionately arge. This is the figure used to epresent the infant, the one both Murillo and Rubens used when painting their angels. Note the two-year-olds n Figs. 26 and 27.

Canon of the six-year-old child. Because the body grows more quickly han the head, the figure now measures ix modules. The trunk is growing onger and wider, gradually acquiring he proportions of the adult. The poition of the chest and the nipples coinides almost exactly with those of the dult. The waist is beginning to grow narrower.

Canon of the twelve-year-old child. This figure measures seven modules and bears a still greater resemblance to an adult figure. Compare this canon with that of the adult, observing how they almost exactly coincide in the poition of the pubis, the navel, and the nipples. However, compared with the dult figure, there is still a marked disproportion between the thorax and the pelvis, due to the continued, premature development of the chest, which is the ame width as the hips. The legs are till short, making the trunk look exaggeratedly long in relation to the rest

26

27

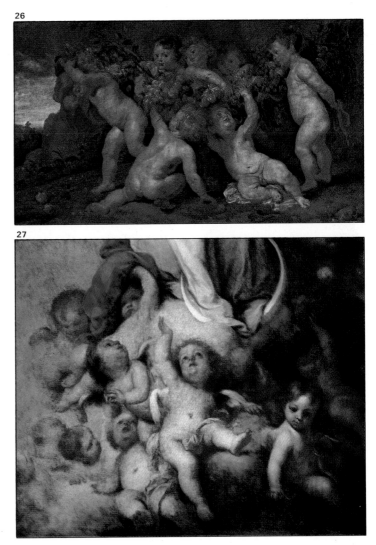

Now is the time to consolidate what we have learned about the ideal proportions of the human body. To start with, we are going to reduce the human body to a plan. This basic structure will permit us to practice the proportions and dimensions, draw a figure in motion, and become familiar with the *ischiatic position* (also called the *hip position*), which is present in many poses, attitudes, and movements. What is more, we are also going to study and practice drawing a figure from memory, a necessary ability that is indispensable when drawing a figure. This chapter contains information and practical exercises to be read and studied with your pencil in hand, ready for drawing and practicing.

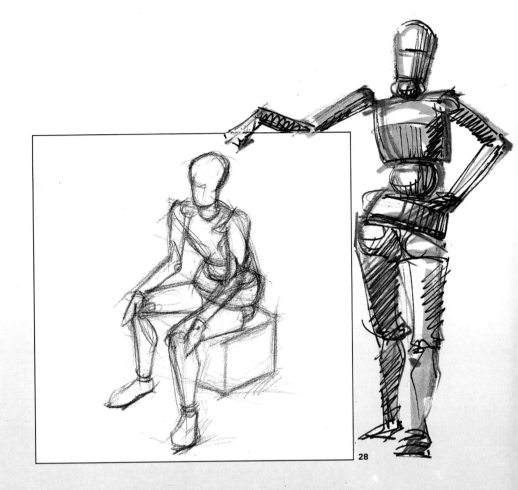

28

CONSTRUCTION
—OF THE—
HUMAN FIGURE

Basic model of the human figure

Now you should have a sheet of paper and a pencil (a soft pencil, such as 3 or 4B) and as you read you must draw some sketches like the ones on this and the following pages. It all deals with reading, learning, and doing it.

We will study a figure whose proportions are identical to the ideal proportions of the human body, showing the head, thorax, and pelvis as in the flesh, but whose extremities, the arms and legs, are shown in skeletal form (Fig. 29).

Let us begin by examining and drawing the shapes, one by one, that make up this model:

The head. It is very similar in shape to the real head, but without a protruding nose or the details of the eyes, the mouth, and the hair. As we noted earlier, this is a simplified model.

The thorax. I have tried to simplify the rib cage area, which is the most complex part of the whole, by means of a series of geometric shapes, as you can see in Fig. 30 A. Although it is only a simplified form, you'll need to practice drawing it several times. Experiment with representing the various positions and movements.

The pelvis. This area, corresponding to the hips and buttocks, is represented by the form of men's bathing trunks or women's bikini briefs. Try to envisage it as a separate, rounded section suspended in mid-air, and copy it from these drawings (Fig. 30 B), making an effort to understand the form and, in particular, the angle or sockets of the thighs. Observe that this form will vary depending on the position and the point of view of the artist.

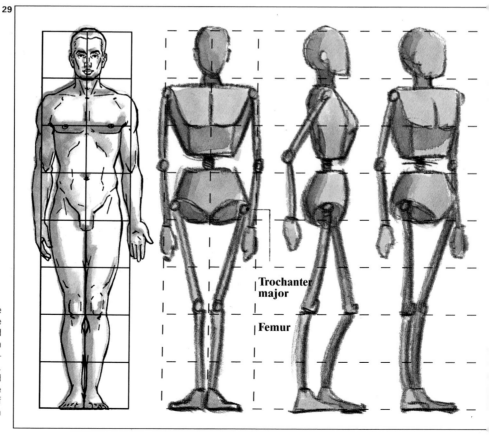

29

Trochanter major

Femur

Fig. 29. Here we can see the human figure reduced to simplified shapes from the front, in profile, and in a three-quarter view. Of course, the proportions and dimensions shown here correspond to a height of eight canons by a width of two canons.

Arms and legs. These are reduced in Fig. 31 to mere lines representing the bones in each of the limbs. Notice at the hip how the femur bones produce the prominence of the *greater trochanter* and converge toward the knees, thus reflecting the actual bone structure of the body. Notice also (in the drawing of the figure in profile) the pronounced forward curve of the *femur* and the backward curve of the *tibia*—the former, because that is the actual shape of the femur, and the latter, because it reminds us of the fleshy curve of the calves. Observe also the forward projection of the kneecap, or *patella*. Reproduce these drawings of the bones, which, although perhaps not entirely faithful to reality, are certainly more expressive.

Hands and feet. For the present, these will be represented in the simplified form illustrated in Fig. 31.

If you have already made a separate study of each of the parts that make up this model, you should now draw it complete and standing erect as shown in Fig. 31.

Draw these five models (Fig. 31) and all subsequent ones about 5 in. (12 cm) high.

The proportions for these drawings should be precisely calculated by dividing each figure into eight equal parts corresponding to the eight heads or modules of the canon. Pencil in the structure faintly, and then draw the figure over it.

Let's suppose that you know how to draw the first model of the human figure and that you can reproduce it *from memory* in the upright position. Now we are going to make that figure move, walk, run, and jump. We are going to bring it to life.

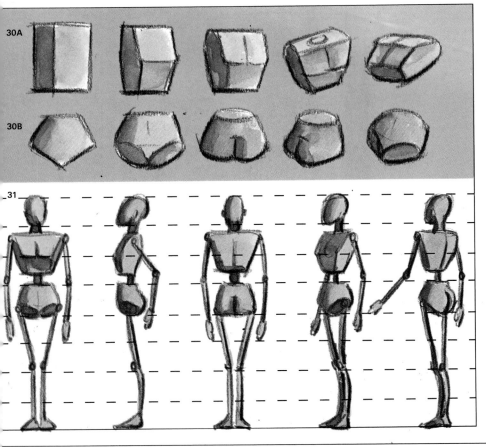

Fig. 30. Study the basic outline of the rib cage and pelvis in the plan of the human figure, which we are now going to draw.

Fig. 31. It is now a question of studying and practicing by drawing a plan of the human figure. Sketch an area of about 5 in. (12 cm) in height, divide it into modules of 2/3 in. (1.5 cm), and draw five plans in it of the standing figure seen from different angles, as shown here.

The ischiatic or hip position

As soon as a figure moves, puts one foot forward, leans on one leg, walks, runs, and so on, it involves a principle that must be properly understood if we are to construct the human figure accurately: the principle of the so-called *ischiatic position*. This term, used by anthropologists, is derived from the fact that a certain bone, *the ischium* (situated in the lower, central part of the pelvis), swings to one side or another, according to the figure's movement or position. Since the movement of the ischium involves the movement of the whole pelvic region, and therefore the hips, this principle can also be called the *hip position*.

What essentially is this principle?

The hip position principle or factor is determined by the position of the pelvis and of the thorax, that is, by resting the body's weight on one leg or the other (Figs. 32 to 34).

Let us return for a moment to our study of the human skeleton. Figure 33 shows a skeleton in the upright, "at ease" position, to use a military expression, with the weight of the body distributed equally on both legs. In the center and lower part of the *pelvis*, you can see that the two bones of the *ischium* are situated on a single, horizontal plane.

Figure 34 illustrates two skeletons in motion, as though they are walking. In both cases, the weight of the body rests on one leg, while the other leg is relaxed, resting as in (A), or moving forward to take another step as in (B). Both show the underlying ischiatic position, that is, where the bones forming the ischium are tilted because the weight of the body rests totally or partially on one leg. Moreover, when the pelvis shifts to one side, the *thorax shifts in the opposite direction.*

Remember that as the figure walks, runs, or even kneels or sits, the hip position factor always—or nearly always—plays a logical role in balancing the weight of the body. Whenever you draw a figure from memory, ask yourself which leg bears the weight of the body and proceed accordingly. Bear in mind also that distribution of weight is a matter of degree. The body may be totally relaxed, as in Fig. 34 A, or only partially relaxed as in Fig. 34 B.

Figs. 32 to 34. When the model adopts the hip position, the pelvis leans to one side, while at the same time the thorax leans to the other (Fig. 34). It is important to know and apply this factor, because, as we can see now, this affects many of the human body's poses.

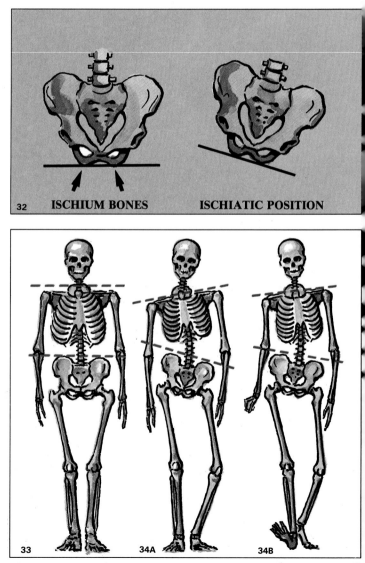

32 **ISCHIUM BONES** **ISCHIATIC POSITION**

33 34A 34B

Remember, too, that sometimes the body's weight is distributed equally on both legs, as, for example, when the figure stands with legs apart, placed symmetrically in relation to the trunk (Fig. 33). In such cases the hip position factor does not come into play. Practice this theory by drawing the models in Fig. 35. Be sure to study and analyze how each position works.

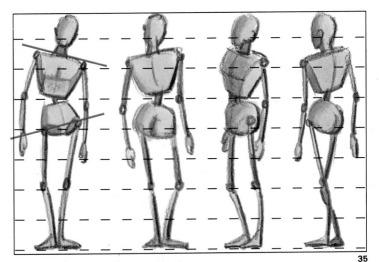

35

Fig. 35. Draw the four plans shown here to study and practice the hip position.

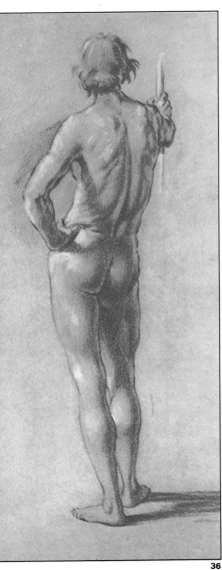

36

37

Figs. 36 and 37. These two drawings provide examples of poses with the model varying the hip position. Fig. 36. Jacques Callot (1592-1635), *A Study of a Male Nude*, sanguine, Uffizi Gallery, Florence. Fig. 37. Joan Sabater. School of Fine Arts of Barcelona.

The figure in action

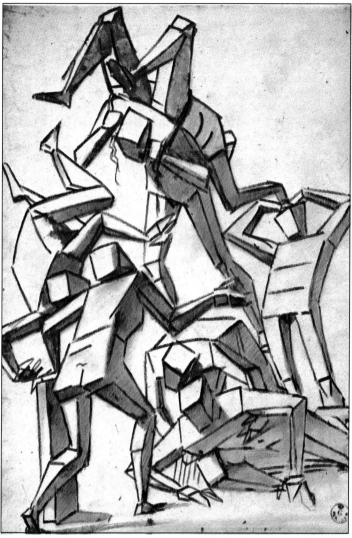

Finally, still using a simple model, draw the figure in action, moving freely– walking, running, running up stairs, sinking into a chair, sitting pensively, talking, gesticulating, fighting, lying on the ground. (See the model in Figs. 39 and 40.) Draw these and other positions; think up new expressions, gestures, and movements. But be careful! Keep an eye on those proportions!

As you practice, remember the advantages of reproducing the model's form without sacrificing a sense of its life and movement. Notice in the drawing on the following page (Fig. 40) how I have occasionally dispensed with the model's waistline. Sometimes I have slightly altered the shape of the bathing costume, constantly trying to envisage and draw the living memory of the human body, rather than the cold, calculated form of its schematic representation.

It is essential to draw the preceding model many times before moving on to the following exercise.

38

Fig. 38. Luca Cambiaso (1527-1588), *Tumbling Men*, Uffizi Gallery, Florence. There have always been artists who were concerned with constructing the human figure through the use of canons, simplifications, or plans, such as those shown here, which were made by an Italian artist of the Renaissance.

Figs. 39 and 40. Study and draw these plans to practice constructing the human figure in motion.

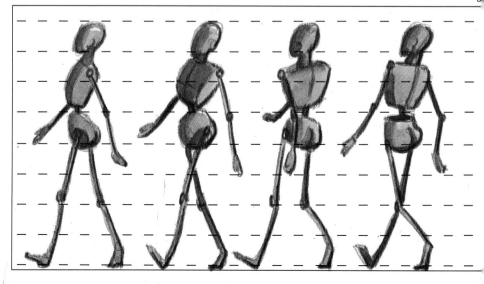

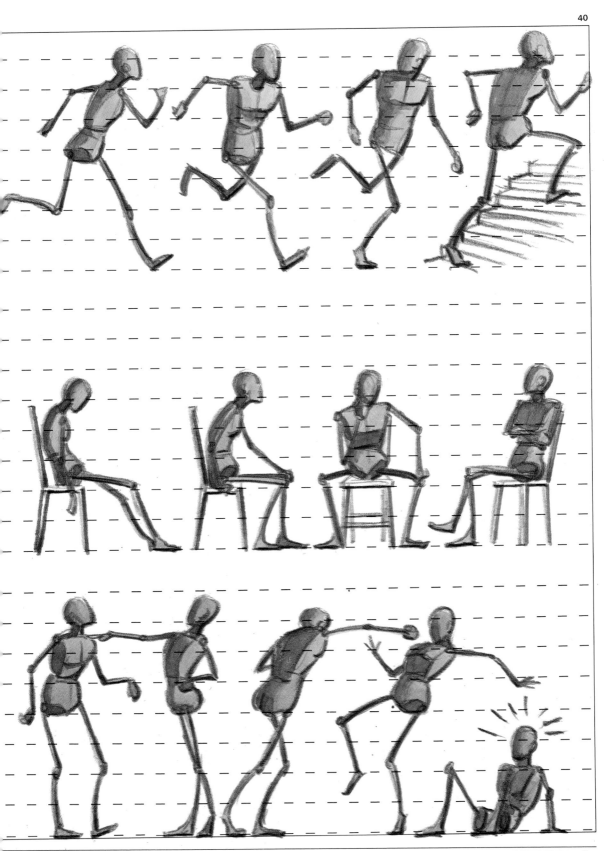

The articulated wooden model

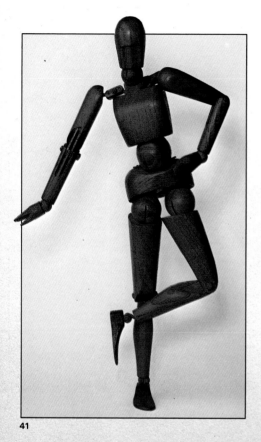

41

foot or an arm to be bent backwards or, likewise, to be put into any position that the human body could not assume.

On this page you can see the sketches for some of these dolls, which are already figure drawings. If you can purchase one, I advise you to do such exercises, trying all kinds of poses, in the certainty that you'll learn the proportion and structure of the human figure. This exercise is very important in my opinion, so if you are unable to obtain one of these professional dolls, I propose you make an *articulated paper doll*. How can you do this?

In the Staatliche Museum in Berlin, one can see an articulated female doll made of wood that was constructed in the 16th century. Vasari, the chronicler of the Renaissance, in his famous book, *Lives of the Artists*, explained that the first to use a doll, or manikin, to draw figures was Fra Bartolomeo. The model of the wooden articulated doll in Fig. 41 is practically the same as, if not identical to, the one Fra Bartolomeo used. You can find better or worse manikins in any good art supply store. The most common model measures between 12 and 14 in. (30 and 35 cm), but there are also bigger ones, and in some fine art schools you can find lifesize ones of 5½ ft. (1.70 m). It is an expensive tool, but it's really useful. The joints of the head, trunk, and extremities allow the student to imitate all kinds of poses and positions, standing up, sitting down, or moving, walking, running, jumping. Note that the system of joints does not allow a

Fig. 41. A wooden articulated doll, about 14 in. (35 cm) high, can be purchased in an art supply store.

Fig. 42. The articulated doll is useful for studying different poses and positions of the human figure in action. Use the doll as a basic model in your work.

42

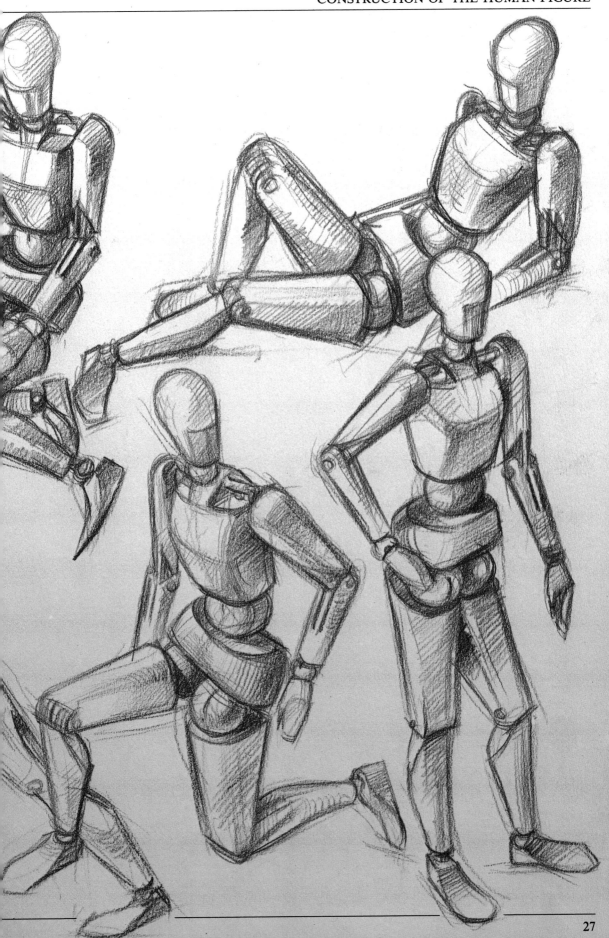

The articulated paper model

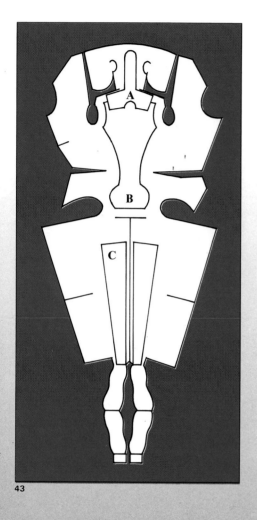

43

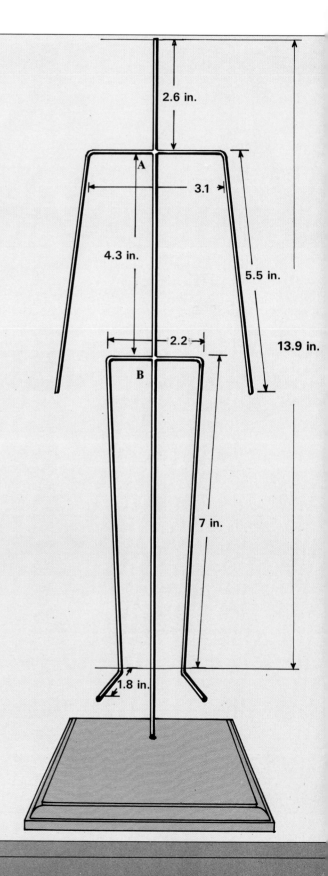

44

You can make a paper manikin or doll like this one by following the instructions on the following pages.

You'll need a piece of white oaktag about 10 × 20 in. (27 × 50 cm) in order to cut out the figure or shape shown in Fig. 43 (the shape's actual size is shown on pages 30–31). You'll also need a wire frame of the size indicated in Fig. 44. As you can see in this figure, the frame is made of three pieces that have to be soldered at points A and B. If soldering is a problem, I recommend that you get a jeweler to do it for you. That's what I did. I gave him the drawing with the sizes for the wire frame and asked him to use wire that could be easily bent. The next day, my wire frame was ready.

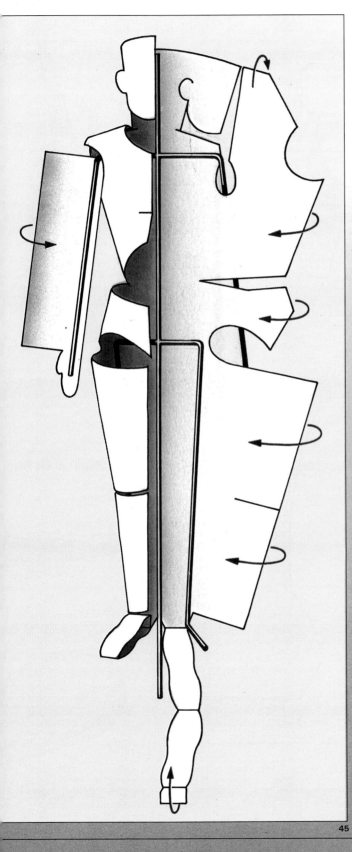

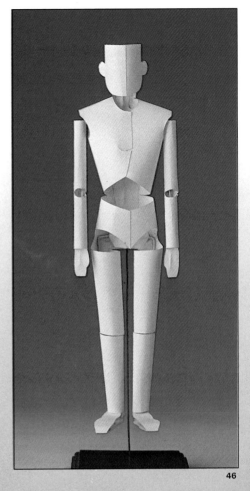

46

Lastly, you should ask a carpenter to make you a small base with a hole in the center that will support the doll as shown in Fig. 44.

Fig. 43. Paper doll pattern with the wire frame attached to pieces A, B, and C. This pattern has no arms. They will be made of two paper cylinders (see them in Figs. 45 and 46).

Fig. 44. The paper doll's skeleton is a wire frame made up of three pieces put together with solder.

Fig. 45. This is how to put the paper doll together once pieces A, B, and C of the wire frame are soldered together. As you can see, the arms are connected afterward.

Fig. 46. Once the left and right sides have been stuck together, the doll is almost ready, except for some touching up.

45

The model of the articulated paper doll

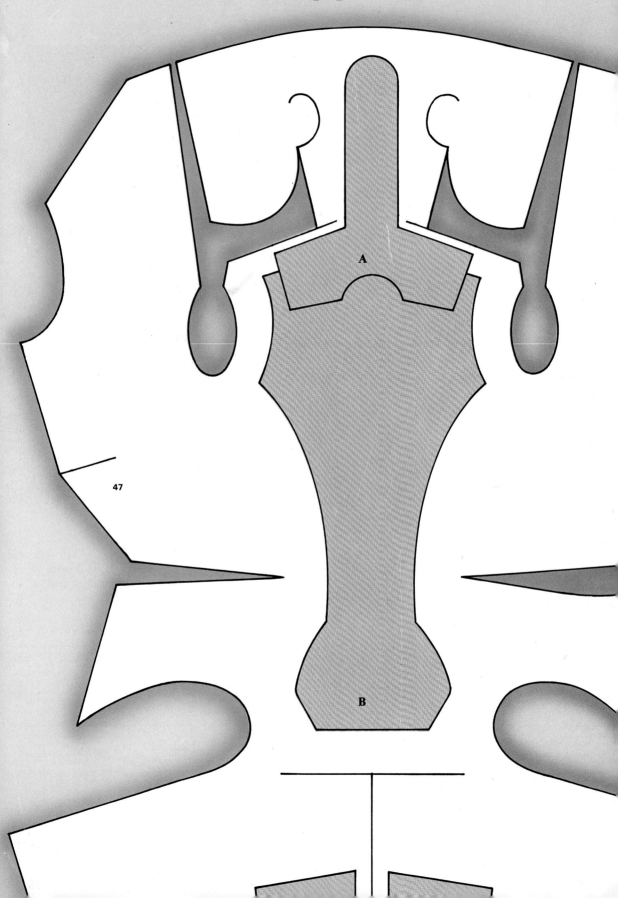

C C

48

Here is the shape or model of the articulated doll at its actual size. See how we divided the figure into two parts (Figs. 47 and 48). What's more, take note of pieces A, B, and C, which you must cut out of separate sheets of paper; *that means these are separate pieces.* Do the same for the arms (piece D).

Now transfer the drawing of the doll to the oaktag. You can do this by tracing against the light, using a window during the daytime. You can draw the whole doll at one time on the oaktag. Begin with the upper part (Fig. 47) and then do the lower part (Fig. 48). Cut out the doll and the additional pieces and mount the doll on the frame, following the instructions given for Fig. 45 on page 29.

D. Pieces that correspond to the arms. You must trace them twice.

How to pose the paper model

It is obvious that this doll does not have joints, so you can vary its posture by bending the wire at points that would correspond to the neck, shoulders, elbows, waist, and so on. Take care that the wire does not break when you try to bend it more than once at the same point. That's why you need to use a flexible wire that can withstand being bent several times in the same place.

As you try out various postures and positions with the paper model, try to make them logical, natural, and believable.

Of course, I am not suggesting that you would dream of bending one of the arms backward as if the elbow joint was inverted. No, that would be unthinkable. But be careful, nevertheless, about how far the arm can be stretched or the leg raised. Bear in mind the movements of the body as they are in reality. Remember, for example, the following:

When walking or running, the up and down movements of the arms are produced in the opposite direction to the movements of the legs (Fig. 49). In most static and seated positions we studied earlier, the hip position comes into effect (Fig. 50).

The body always tries to maintain its equilibrium. When the trunk leans to one side, forward or backward, the arms instinctively rise and extend in the opposite direction (Fig. 51).

Figs. 49 to 51. As yo can see in the illustra tions, the paper model a lows the reproduction o almost all the move ments of the huma body. But you must tak into account that move ments must be logica natural, and possible Remember, for instance that when walking th arms swing in the oppo site direction to the legs when carrying a weigh on an arm, the opposi arm stretches.

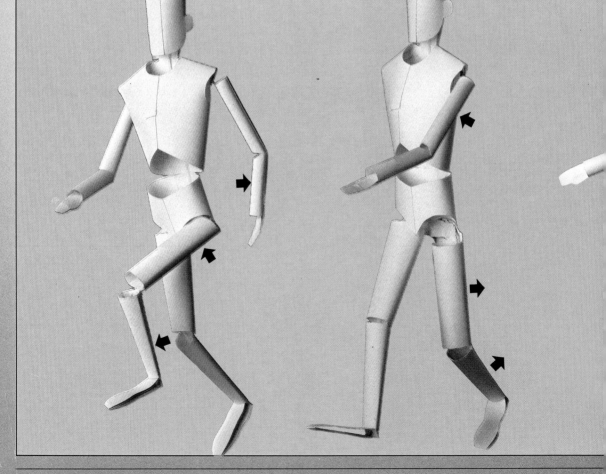

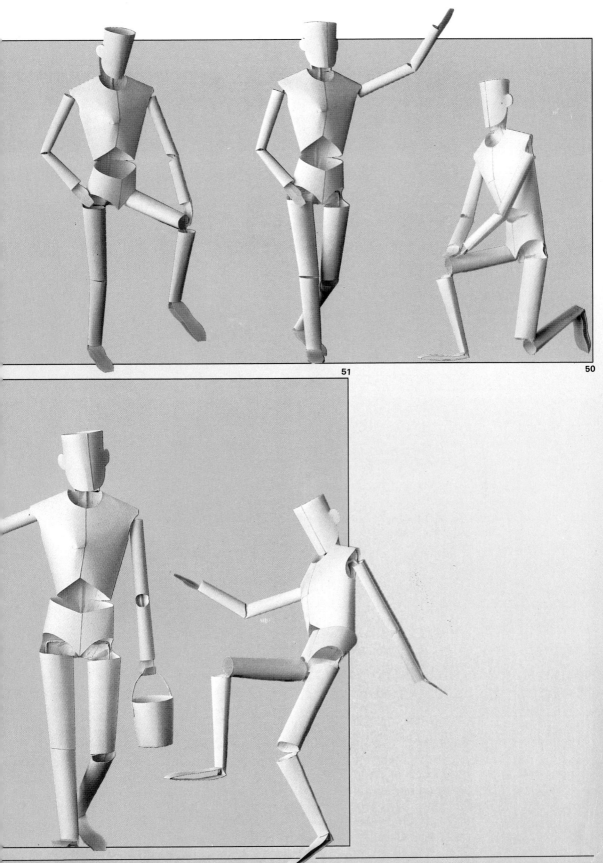

Drawing the paper model

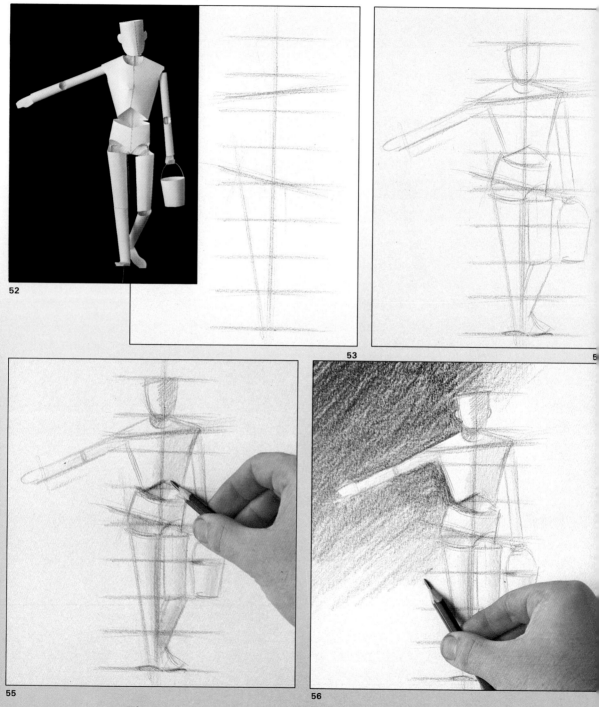

52

53

55

56

Final stage: Now that you have the paper doll ready and mounted, all you have to do is work with it, drawing it again and again in different postures and poses. Let's begin. I'm going to do it myself in the short step-by-step study reproduced on these pages. First,

I think about and select the doll's pose. It's similar to one of the poses I showed you on the preceding page: figure walking with a weight, say, a bucket of water, in its left hand, a posture that is conditioned by the hip position (Fig. 52).

I start the drawing by sketching a guide divided into eight modules (the eight heads of the canon). Now determine the hip position and the symmetrical center of the body (Fig. 53).

Next, sketch the general structure of the doll. Draw it with a soft 4B pencil. The drawing should be about 1 in. (18 cm) high (Fig. 54).

With pencil in hand, I make the first rough drawing and calculate the relation of tones (Fig. 55).

I "paint" in the background, starting in the lower lefthand corner. The shaded part outlines the figure on the illuminated side. The color tones are perfected by graying and shading the figure. I alternate using the pencil with finger stumping (Figs. 56 and 57).

I finish by touching up with the pencil and then opening up and drawing some whites and highlights with the malleable eraser (Fig. 58) until the picture is completed (Fig. 59).

Figs. 52 to 59. Study attentively this process and do it yourself with the paper doll in the position we suggest or any you choose.

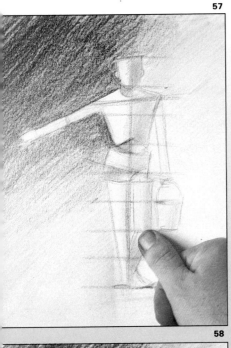

57

58

59

Perspective and anatomy are two subjects the artist or figure painter cannot afford to ignore. The human body is made up of spherical planes and cylinders, as we will see shortly, and drawing these forms is always conditioned by perspective. Knowledge of artistic anatomy is an integral part of painting and drawing a figure, especially a nude. The artists of the Renaissance understood this and went into the hospitals and morgues for the first time, according to Leonardo da Vinci in his *Treatise on Painting,* to study corpses, at the same time suffering terrible nausea and vomiting, all to discover the inner secrets of the human body.

60

PERSPECTIVE
—AND—
ANATOMY

Perspective applied to the human figure

Our paper doll model is a great aid in studying and understanding the importance of perspective when constructing the human figure. It brings home to us that frequently repeated truth that "the human body is composed of a series of cylindrical forms."

Do you remember how to represent a cylindrical form in perspective? Do you know its appearance is affected by being seen from above or below? Make sure you are familiar with these basic effects by consulting Fig. 61. This shows a series of small can-shaped cylinders, placed at intervals one above the other. Apart from the accurate representation of each cylinder, the most important thing to remember here is that *the farther the cylinders are from the horizon, the more clearly their spherical planes can be seen. Bear in mind that (1) the cylinders situated above the horizon show their lower spherical surfaces, while (2) those situated below the horizon show their upper spherical surfaces.*

61

Fig. 62. The basic structure of the human body is made up of spherical planes and cylinders. When we see a figure near us, the perspective of the spherical planes and cylinders that give form to the different parts of the human body is accentuated.

62

Fig. 61. A series of small cylinders separated from one another and placed in a column can convey the effect of perspective. The farther away the cylinders are from the horizon line, the more visible their spherical planes will be.

The human figure poses the same problem of perspective: In the construction of the trunk and, in particular, of the arms and legs, the same rules of perspective apply as for cylindrical objects.

Notice in Fig. 62 that by placing the horizon level with the head, and supposing that the figure is relatively near us, the same perspective operates as in the case of the tin cans. That is, the spherical planes are perceived in the same way, at more or less of an angle, depending upon their relative distance from the horizon line.

Observe another example of how this rule applies to drawing the human body in Fig. 63. Notice one point clearly illustrated here: When the figure is seen from above—or below—our perception of the whole body is altered by perspective. The line of (A) the shoulders and the line formed by (B) the feet coverge toward a single vanishing point.

ORIZON LINE

VANISHING POINT

Fig. 63. A seated figure seen from an elevated point of view allows us to appreciate the perspective of the cylindrical forms and structures of the human body. Note how the eyebrows, shoulders, nipples, knees, ankles, and feet are all conditioned by perspective.

63

Canon-block perspective of the human figure

Until now, we have taken for granted your knowledge of *perspective, horizon line,* and *vanishing point,* and although you understand what they are it would be helpful to review the basic facts again very briefly.

The fundamental elements of perspective are the *horizon line,* which is situated at eye level when you are looking forward, and the *viewpoint* (VW) and the *vanishing points* (VP), at which the perpendicular and oblique lines converge (Fig. 64).

There are two basic types of perspective: *parallel perspective,* with only one vanishing point, and *oblique perspective,* with two vanishing points (Figs. 65–68). Note that the rectangular solid is the ideal basic form with which

to structure any body (Fig. 64).

Forget about the cylinders and the cans for a moment, and imagine the figure encased within a parallelepiped, that is, a long, thin, rectangular block constructed according to the proportions of the canon: eight modules high, two modules wide, and almost one and a half modules deep. Put this block in perspective, and, of course, the dividing lines A, B, C, and so on will converge at the vanishing point, as will the dividing lines a1, b1, c1, and so on. Similarly, by putting the human figure in this box, we see that the lines or levels formed by the shoulders, nipples, elbows, hips, and so on down to the feet are seen in perspective (Fig. 69).

Figs. 65 to 68. See in the figures several rectangular blocks in oblique perspective with two vanishing points.

VANISHING POINT (VP.1)

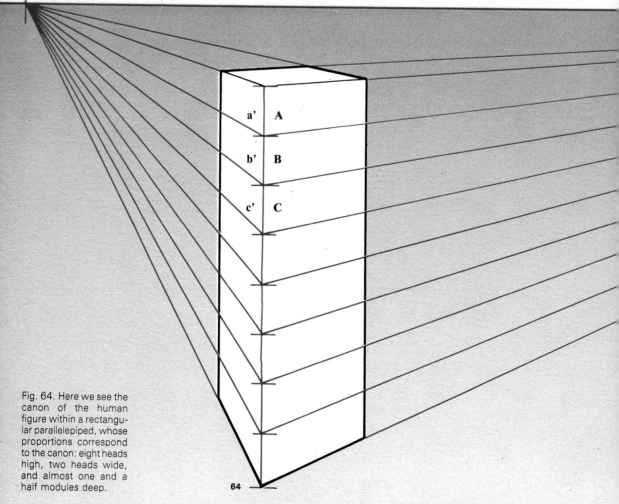

Fig. 64. Here we see the canon of the human figure within a rectangular parallelepiped, whose proportions correspond to the canon: eight heads high, two heads wide, and almost one and a half modules deep.

64

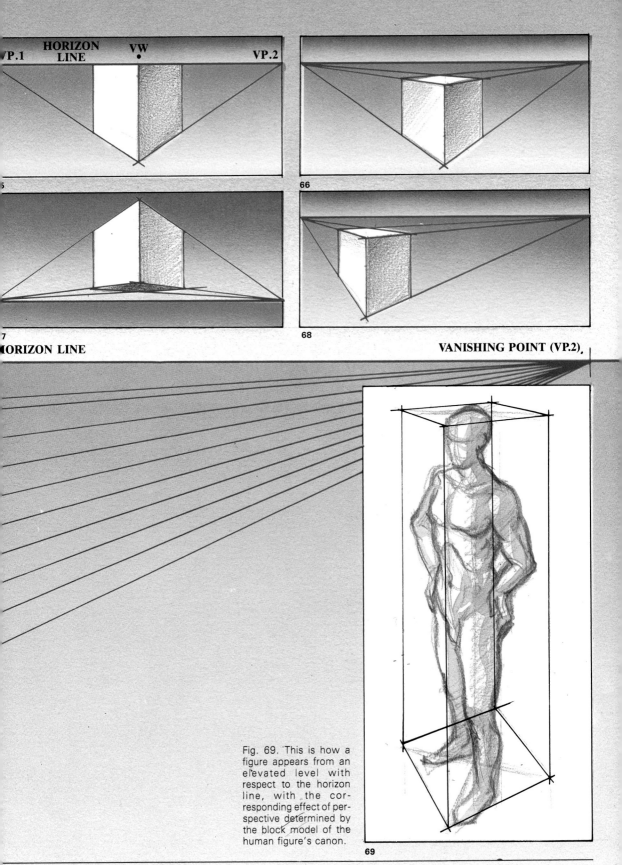

HORIZON LINE VW VP.1 VP.2

HORIZON LINE VANISHING POINT (VP.2)

Fig. 69. This is how a figure appears from an elevated level with respect to the horizon line, with the corresponding effect of perspective determined by the block model of the human figure's canon.

69

How to place several figures in perspective

The artist often has to draw several figures in relation to a given horizon in a single picture. When this need arises, the problem of perspective may be solved in the following manner:

When we draw a single figure, we've already seen that the perspective i resolved by means of the cylindrica forms in the human figure, along with the application of the canon model a a guide to the lines and forms that con verge on the horizon. But what hap pens when we include two or mor figures, on different levels, such a figures going up or down stairs? When a painting or illustration ha more than two figures in it, *there is al ways a relationship of sizes based on*

Fig. 70. Take note of the fact that in this picture *there is a proportional and perspectival relationship* between the different figures, which is determined by the modules of the human canon. In order to work out this proportional relationship in perspective, see the series of formulas used by professionals on the following pages.

70

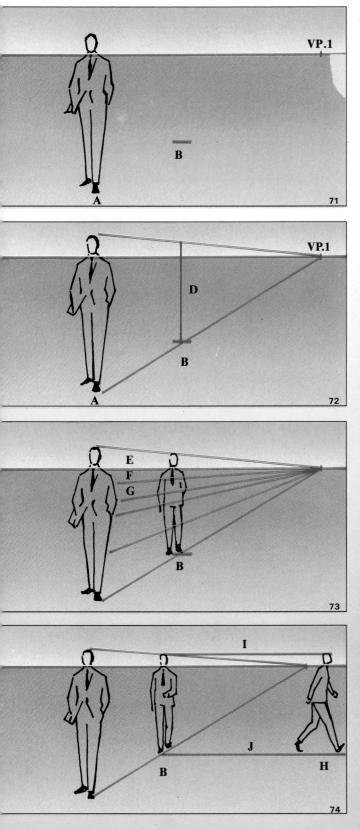

proportions and perspective. This rule is illustrated in Fig. 70. It clearly shows that among figures A, B, and C, the last is proportionally greater than B, while B is proportionally greater than A. But let me go further in explaining this interesting problem of perspective in the following pages.

Figure 71. We are going to show, step by step, the problem of positioning various figures in different places in the same picture, all the time maintaining relationships of proportion and perspective that we have discussed. We start by sketching the horizon line. Afterwards, we must situate and proportion one of the figures (A) with our eye. Then we determine the place where we will put another of the figures (B).

Figure 72. To find the height and proportions of the second figure, we have to sketch an oblique line from A to the vanishing point (VP 1) going through B. Then, we draw another oblique line from the head of the first figure to VP 1. Lastly, we draw the vertical line D between the two oblique lines at B.

Figure 73. The vertical line D gives us the height of the second figure, B. The proportions of B come from the oblique lines E, F, G, starting from the neck, breasts, waist, and knees of the first figure.

Figure 74. Supposing you need to place another figure H in the drawing. In order to find H at the same level as B, all you have to do is draw the horizontals I and J to determine the height and proportions of the third figure.

Figure 75. We now want to locate another figure in the picture. What height and proportions should it have with respect to the others? Start by sketching an oblique line from E on figure A *to any point along the horizon, in this case VP 2.*

Figure 76. This line, K, allows us to obtain point L. From there we draw vertical line M, and obtain a new point, N. (Points L and N came from the oblique lines drawn from the first figure. See Fig. 72).

Figure 77. Now, by joining VP 2 to N and continuing it to O, we obtain the desired height P. In order to determine the proportions of this fourth figure, all we need to do is project those drawn in the initial figure A.

Figures 78 to 80. This is the solution. We can also see the same formula of perspective applied to a picture with a low horizon (Fig. 79) and to a picture with a high horizon (Fig. 80).

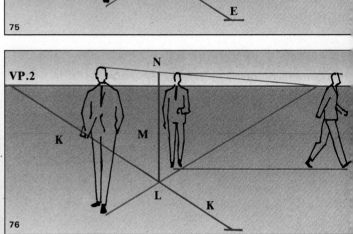

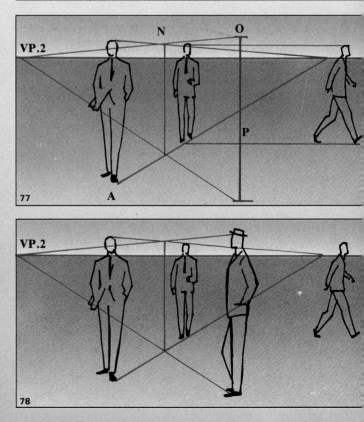

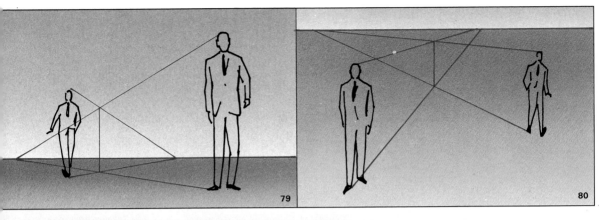

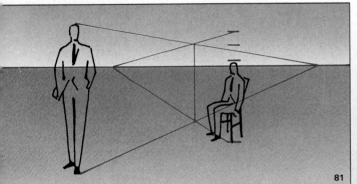

Figure 81. In order to draw the figure of a woman, which is lower than that of a man, or a child or seated figure, we divide the normal height into eight equal spaces and use six for the seated figure, seven for the woman, and as many as we consider necessary, according to age, for the child.

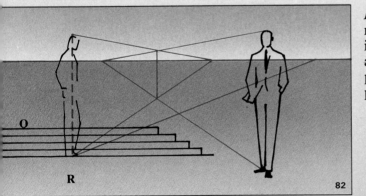

Figure 82. When the figure is on a more elevated plane (Q), we start by imagining that it is on the same plane as the other figure (R), and project its perspective using the formula we explained previously.

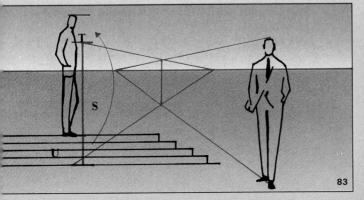

Figure 83. With this, we obtain the vertical line S. Adding the distance U to the point T, we get the height of the figure on the most elevated plane. As you can see, it is a question of "taking the figure down from a pedestal" to calculate the height and "putting it back" afterward to locate it proportionally in perspective.

Studying anatomy is necessary

Just like the sculptors of ancient Greece, you and I can also represent the human figure without understanding human anatomy. All we have to do is observe the model and *copy* it. But the artists of the Renaissance, like the painters and sculptors Michelangelo and Leonardo da Vinci or such celebrated painters as Veronese, Raphael, and Titian, all considered it necessary to know the artistic anatomy of the human body in great depth. In this respect, Ingres said, "In order to explain the surface of the human body, we must first comprehend its muscular and bone structure."

As a testimony to the importance of artistic anatomy for great masters of painting and drawing, you can see on these pages some studies of the human figure in which anatomy has prime importance (Figs. 84 to 87).

84

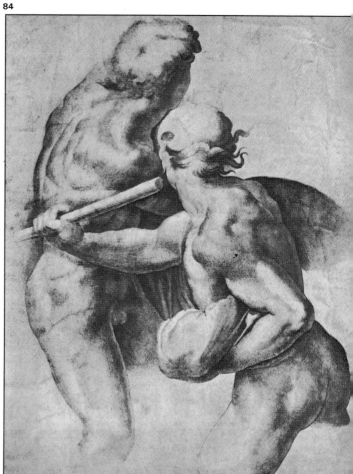

85

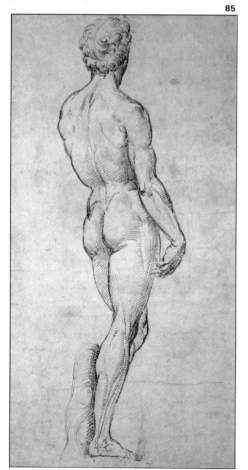

86

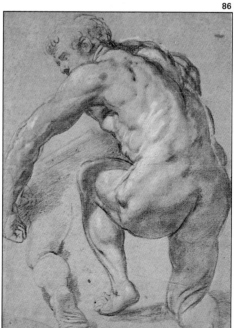

Figs. 84 and 85 Michelangelo (1475-1564), *Two Male Torso Seen from Behind*, Academy Museum Venice. Raphael, *Nud Male*, British Museum London. In the middle of the 16th century, the dis section of corpses wa prohibited in Italy Michelangelo was ac cused of being a "vil profaner," it is said, "fo slitting open from top to bottom, in order to lear about art, the dead bod of one of the Corsini," noble family of Florence But Michelangelo an Raphael, as well as man other artists, continue to study corpses in or der to draw studies i which the anatomica relief was a fundamenta realistic factor.

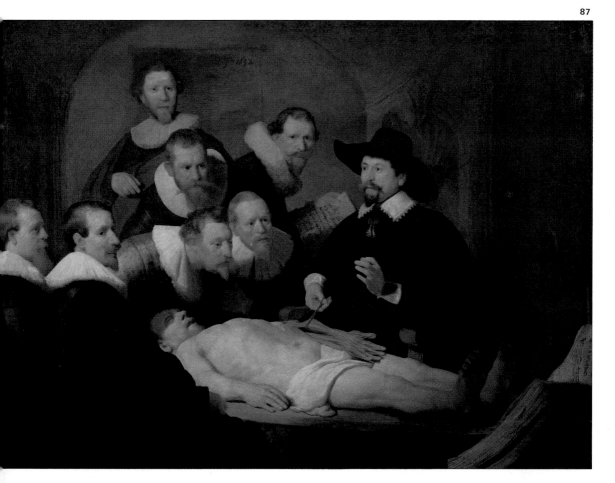

Fig. 86. Peter Paul Rubens (1577-1640), *Nude Man on His Knees*, Boymans-van Beuningen Museum, Rotterdam. Rubens was one of the greatest painters of the human figure; he drew hundreds of studies showing the anatomy of the human body.

Fig. 87. Rembrandt van Rijn (1606-1669), *Doctor Tulp's Lesson in Anatomy*, Mauritshuis, The Hague.

Rembrandt painted this famous picture at the age of twenty-five. The dissection of corpses was no longer a crime, but was considered an event. In January 1632, Doctor Tulp, a top anatomist in the Amsterdam Association of Surgeons, gave a public lesson on physiology using the corpse of an executed person. The Amsterdam Association of Surgeons wanted to immortalize the event and commissioned young Rembrandt to paint it. It is well known that this opened the doors to fame and prosperity for Rembrandt, who from then on received many commissions to paint portraits of individuals, couples, and groups.

Rembrandt painted *Doctor Tulp's Lesson in Anatomy* in 1632. One year before, Peter Paul Rubens had married Hélène Fourment, who became his muse and model in his paintings on mythological themes, in which Rubens continued to demonstrate his knowledge of anatomy. Times had also changed in Italy. In Bologna, the artists and brothers Agostini and Annibale Carracci, along with their cousin Ludovico Carracci, founded the Academy of the Incaminati. At the start it was called the Natural Academy because the artist and professor Dr. Lanzoni gave classes in anatomy.

General principles of muscular structure

1. Muscles are the organs that activate body movements because of their ability to contract and relax.
2. Muscles are divided into two groups:
 a. *Flat muscles*, which contract slowly and involuntarily.
 b. *Striated muscles*, which contract quickly and voluntarily. It is these muscles that we artists have to study.
3. Generally, muscles are made up of bunches of muscular fibers that terminate in one or more tendons, linking the muscles to the bones.
4. The shape of the muscles varies in keeping with the function, and can be classified as:
 a. *Circular* b.*Orbicular* c. *Flat and broad* d. *Fan-shaped* and e. *Spindle-shaped*, the most visible because of their shape: bulky in the middle like the *biceps* that move and flex the arm.

5. Most of the movements that tak place in the mobile bones of th skeleton are controlled by the *leve principle, determined by two forces power* and *resistance*.

In Figs. 88 and 89, we show the arn movement as an example of the leve principle.

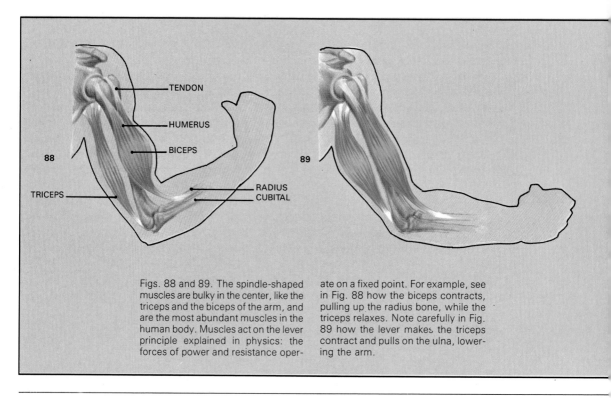

88

89

TENDON

HUMERUS

BICEPS

TRICEPS

RADIUS
CUBITAL

Figs. 88 and 89. The spindle-shaped muscles are bulky in the center, like the triceps and the biceps of the arm, and are the most abundant muscles in the human body. Muscles act on the lever principle explained in physics: the forces of power and resistance oper- ate on a fixed point. For example, see in Fig. 88 how the biceps contracts, pulling up the radius bone, while the triceps relaxes. Note carefully in Fig. 89 how the lever makes the triceps contract and pulls on the ulna, lowering the arm.

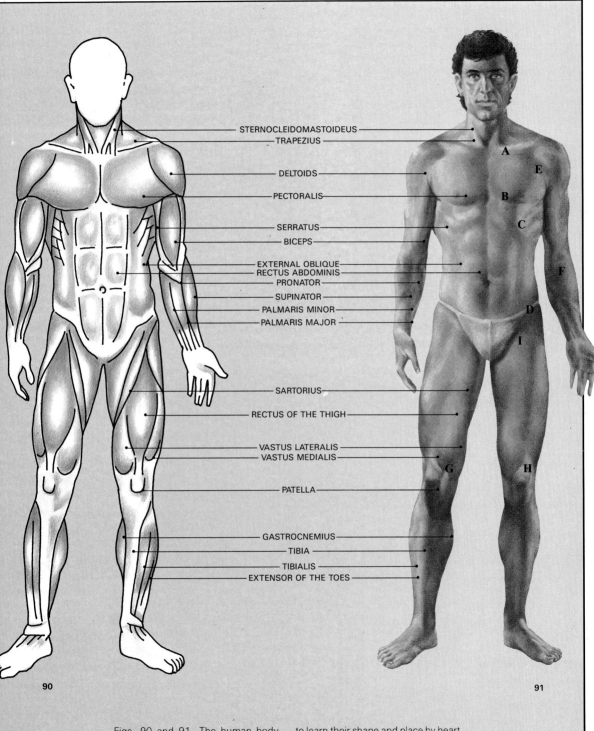

STERNOCLEIDOMASTOIDEUS
TRAPEZIUS

DELTOIDS

PECTORALIS

SERRATUS
BICEPS

EXTERNAL OBLIQUE
RECTUS ABDOMINIS
PRONATOR
SUPINATOR
PALMARIS MINOR
PALMARIS MAJOR

SARTORIUS

RECTUS OF THE THIGH

VASTUS LATERALIS
VASTUS MEDIALIS

PATELLA

GASTROCNEMIUS
TIBIA
TIBIALIS
EXTENSOR OF THE TOES

90

91

A
E
B
C
F
D
I
G
H

Figs. 90 and 91. The human body seen from the front shows a series of muscles that you can see in the muscular plan on the left and in the real body on the right. I ask you not just to read and look at them. Take the time to learn their shape and place by heart by drawing them in the linear plan shown in Fig. 90. This step is the best way to learn artistic anatomy of the human body.

Principal muscles of the human figure. Front view

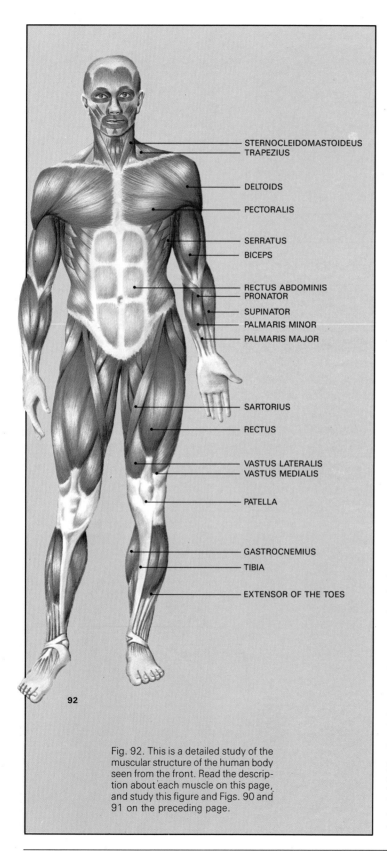

STERNOCLEIDOMASTOIDEUS
TRAPEZIUS

DELTOIDS

PECTORALIS

SERRATUS
BICEPS

RECTUS ABDOMINIS
PRONATOR
SUPINATOR
PALMARIS MINOR
PALMARIS MAJOR

SARTORIUS

RECTUS

VASTUS LATERALIS
VASTUS MEDIALIS

PATELLA

GASTROCNEMIUS
TIBIA

EXTENSOR OF THE TOES

92

Fig. 92. This is a detailed study of the muscular structure of the human body seen from the front. Read the description about each muscle on this page, and study this figure and Figs. 90 and 91 on the preceding page.

Study Figs. 90 to 96 on pages 49-5:

Sternocleidomastoideus. This musc appears as a V shape in the neck an may emphasize the small triangula cavity formed by its two lower se tions.

Pectoralis. This muscle covers th chest. The bunches of muscles con posing it combine to form a strong short tendon that is controlled by th humerus bone underneath the deltoi muscle.

Serratus. It can be seen on muscula people on both sides of the thorax.

Rectus abdominis. This muscle is mad up of three or four pairs of rectangle along the center of the abdomen an stomach.

Deltoids. These muscles form a kin of cap over the ends of the shoulde

Biceps. These muscles can be seen o the front surface of the arm even whe they are relaxed.

Pronator. This muscle lies obliquel across the inside of the forearm nea the joint.

Supinator. This muscle is primaril used to bend the arm.

Palmaris minor and palmaris majo These muscles can be seen when th hand is bent back over the forearm

Rectus of the thigh, vastus medialis and vastus lateralis. These are th muscles that form the shape of th thigh as seen from the front.

Sartorius. This is a long strip of mus cle running obliquely across the fror of the thigh.

Gastrocnemius. We'll study this whe we examine the rear view.

Tibia. This is a bone, not a muscle. W show it and the **patella** so that you wi remember how close to the surface it i

Extensor of the toes. This muscle i found on the outer side of the leg.

Trapezius. This whole muscle forms a irregular quadrilateral area on the up per part of the back behind the nec and shoulders. When the whole mus cle operates, it moves the scapul toward the middle of the back, where

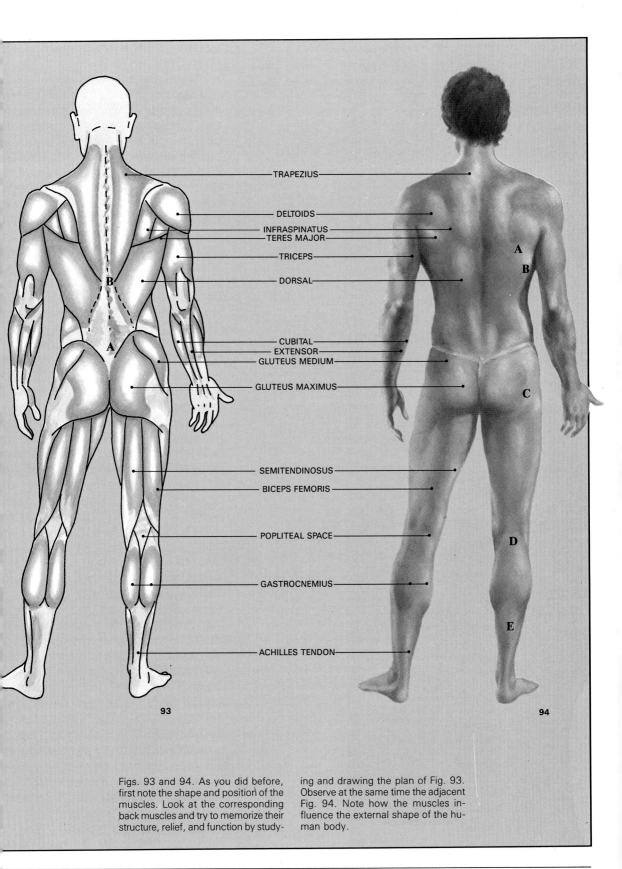

TRAPEZIUS

DELTOIDS

INFRASPINATUS
TERES MAJOR

TRICEPS

DORSAL

CUBITAL
EXTENSOR
GLUTEUS MEDIUM

GLUTEUS MAXIMUS

SEMITENDINOSUS

BICEPS FEMORIS

POPLITEAL SPACE

GASTROCNEMIUS

ACHILLES TENDON

93 94

Figs. 93 and 94. As you did before, first note the shape and position of the muscles. Look at the corresponding back muscles and try to memorize their structure, relief, and function by study-ing and drawing the plan of Fig. 93. Observe at the same time the adjacent Fig. 94. Note how the muscles in-fluence the external shape of the hu-man body.

Principal muscles of the human figure. Back view

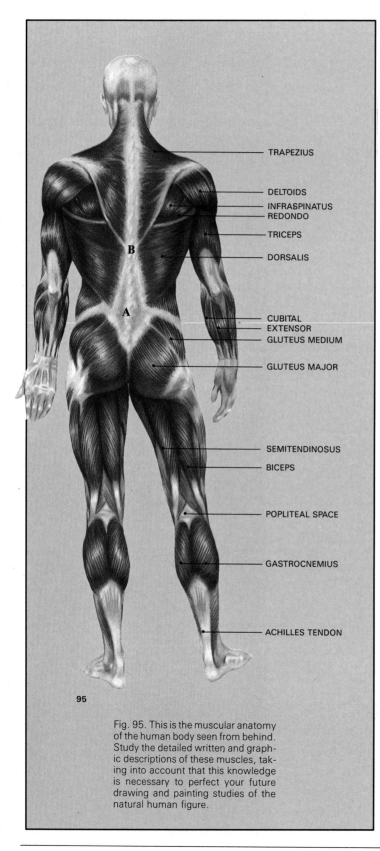

TRAPEZIUS

DELTOIDS

INFRASPINATUS
REDONDO

TRICEPS

B

DORSALIS

A

CUBITAL
EXTENSOR

GLUTEUS MEDIUM

GLUTEUS MAJOR

SEMITENDINOSUS

BICEPS

POPLITEAL SPACE

GASTROCNEMIUS

ACHILLES TENDON

95

Fig. 95. This is the muscular anatomy of the human body seen from behind. Study the detailed written and graphic descriptions of these muscles, taking into account that this knowledge is necessary to perfect your future drawing and painting studies of the natural human figure.

by its lateral and upper edges becom prominent.

Infraspinatus and teres major. The two muscles cover the triangle forme above and on both sides of the scapu lae. The infraspinatus is particular obvious, but it rarely hides the surfac outline of the scapulae (A in Fig. 94

Dorsal muscles. Notice in Fig. 95 th shape and position of the dorsal mu cles. The aponeurosis, the diamon shape in the middle and base of th back (A in Fig. 95), is a flat, muscula tendon. The dorsal muscle is thin at th aponeurosis and thick near the rib producing at the armpit the wel known, long dorsal bulge (B in Fig 94). When the body is bent backward the dorsal contracts, bringing out th aponeurotic line (B in Fig. 95).

Gluteus maximus. This is the bulkie muscle in the buttocks. It is relaxed c partially relaxed when the body i standing still. When the body is ber backwards and the muscles contrac the buttocks change shape, stretchin in a lateral direction (C in Fig. 94).

Semitendinosus and biceps femoris These are the muscles that shape th rear of the thigh. They become ver evident on the surface, emphasizing th two end tendons at both sides of th patella. The manner in which thes tendons separate and then becom linked with the gastrocnemius pro duces the rhomboid-shaped cavity o the **popliteal space** (D in Fig. 94).

Gastrocnemius. This is the calf mus cle. It begins as two separate units i the popliteal space and then combine to form the **Achilles tendon**—the thick est and most powerful tendon in th entire body. The gastrocnemius' bulky, rounded shape is characteristi of the calf and emphasizes the depres sion formed when it joins the Achille tendon (E in Fig. 94).

In the figure seen in profile the sam muscles as in the previous figures ap pear again, in addition to:

Radial. It lies in the forearm beside th supinator and bends the hand back

Principal muscles of the human figure. Profile view

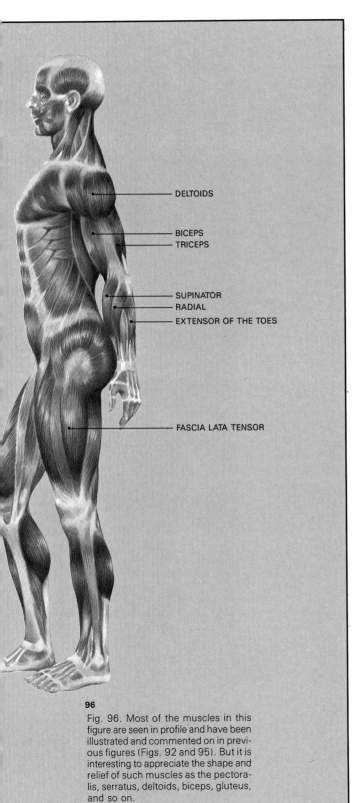

DELTOIDS

BICEPS
TRICEPS

SUPINATOR
RADIAL
EXTENSOR OF THE TOES

FASCIA LATA TENSOR

96

Fig. 96. Most of the muscles in this figure are seen in profile and have been illustrated and commented on in previous figures (Figs. 92 and 95). But it is interesting to appreciate the shape and relief of such muscles as the pectoralis, serratus, deltoids, biceps, gluteus, and so on.

ward (stretching the hand). Its shape converges with the supinator's and they appear as a single muscle. It is nevertheless noticeable in muscular arms when the hand carrying a weight is stretched and bent upon the forearm. **Fascia lata tensor.** It is located in the outer side of the thigh, attached up to the ileac crest and down to the tibia top. It is a tensor of the femoral aponeurosis—the lighter string, also called fascia lata—, and operates in the bending and stretching of the thigh and in keeping the body balanced when the body stays on one leg. It has an extraordinary profile, noticeable when the thigh is bent and in any ordinary situation, since complete relaxation is not usual (Fig. 96).

This is the end of the visual study of the principal muscles of the human body. I can say no more, but you should study carefully the definitions and learn by heart how the muscles are, where they are placed, and what they do.

Practical exercises in anatomy

Once you have finished your correctly structured and proportioned sketch, using the paper doll as a model, ask yourself where the various muscles are located and what shape the pectoral muscles, the deltoids, and the biceps have when viewed from a given position. Imagine and establish the *central line of symmetry of the human body* (Fig. 99). Lightly sketch the outline in perspective and draw the muscles (Fig. 100). Naturally, this requires a fairly thorough knowledge of anatomy, which can only be achieved through constant study and drawing of the human figure. Try it. Draw it. Repeat the drawing. Look at the sketches I have made, which are reproduced on the following pages (Fig. 99 to 114).

My advice is that you start this study using real figures seen from the front, progressing to the three-quarter position, and finally to the back view. Then manipulate the paper doll into a walking position and draw it from the front, in the three-quarter position, and finally in a walking position seen from behind.

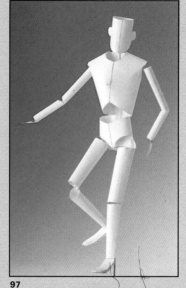

97

98

Figs. 97 to 99. Study and sketch the paper doll (Fig. 97). Draw a few quick strokes to check the pose (Figs. 98 and 99).

99

Fig. 100. Draw a study showing the construction and anatomy of the male figure, which you started with the model and previous sketches. You can draw it with a soft 3 or 4B lead pencil, or you can use a sanguine pencil or even a brown-colored pencil.

100

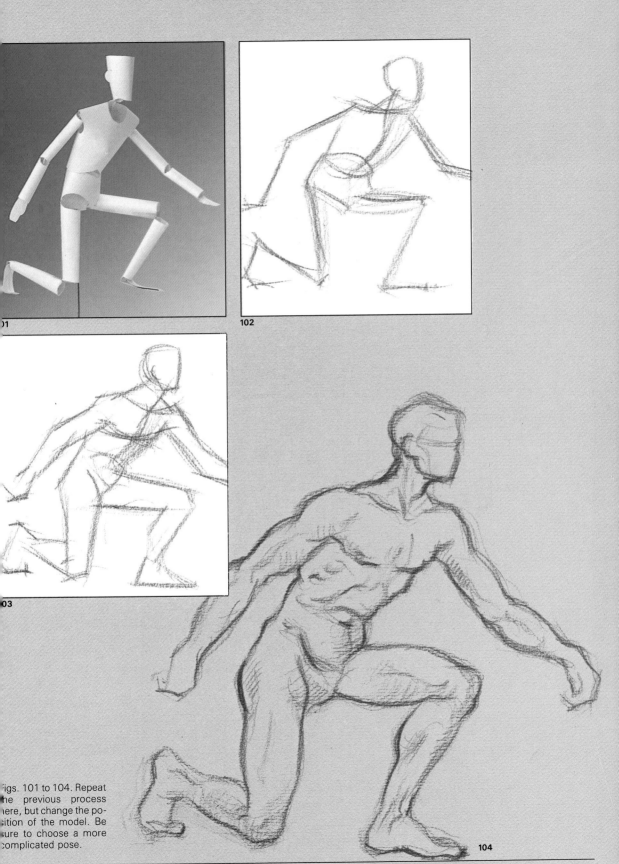

101

102

03

Figs. 101 to 104. Repeat the previous process here, but change the position of the model. Be sure to choose a more complicated pose.

104

Exercises in the construction of the male body

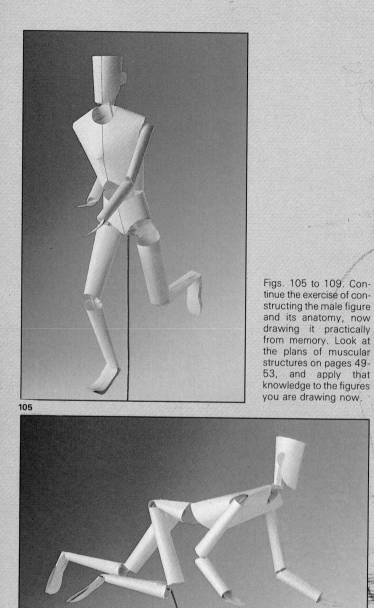

Figs. 105 to 109. Continue the exercise of constructing the male figure and its anatomy, now drawing it practically from memory. Look at the plans of muscular structures on pages 49-53, and apply that knowledge to the figures you are drawing now.

105

106

107

108

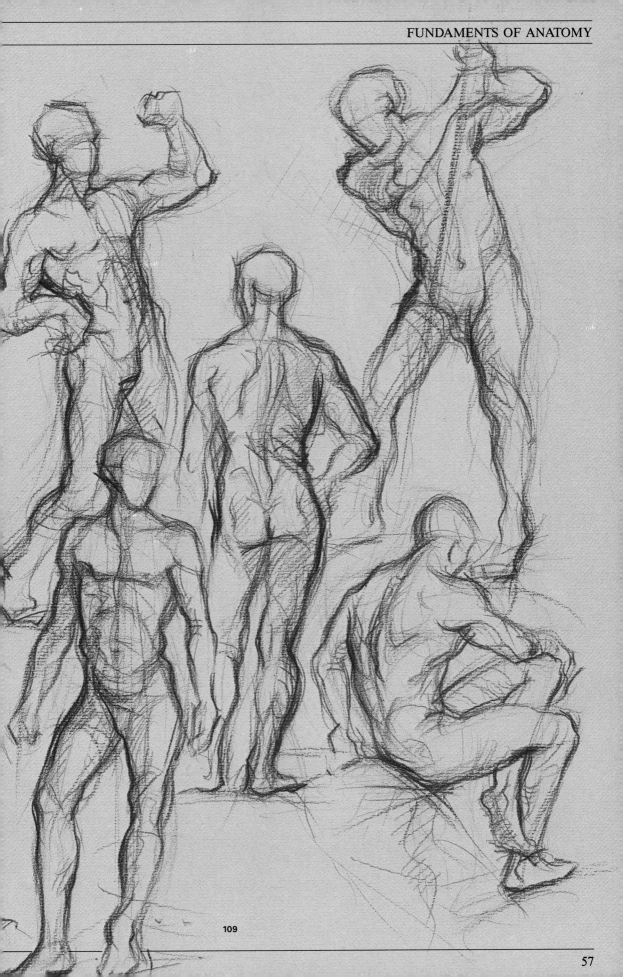

Exercises in the construction of the female body

110

112

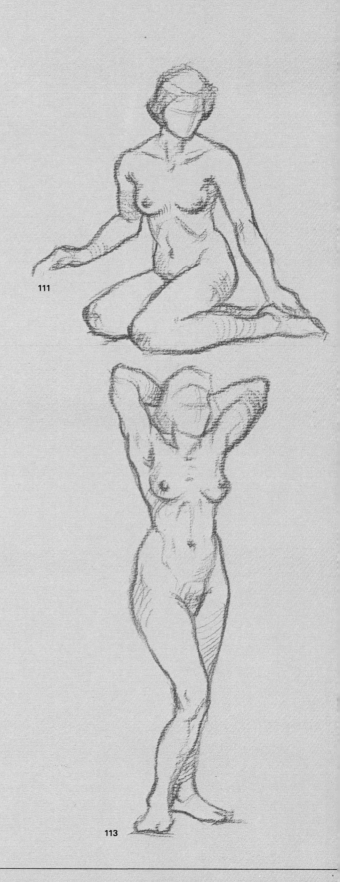

111

113

Figs. 110 to 114. The problem here is more of structure and construction than of anatomy, as that is not so evident in the female body. Fix the poses of the paper doll and consult the canon of the female figure (Fig. 18) in order to construct and proportion these sketches.

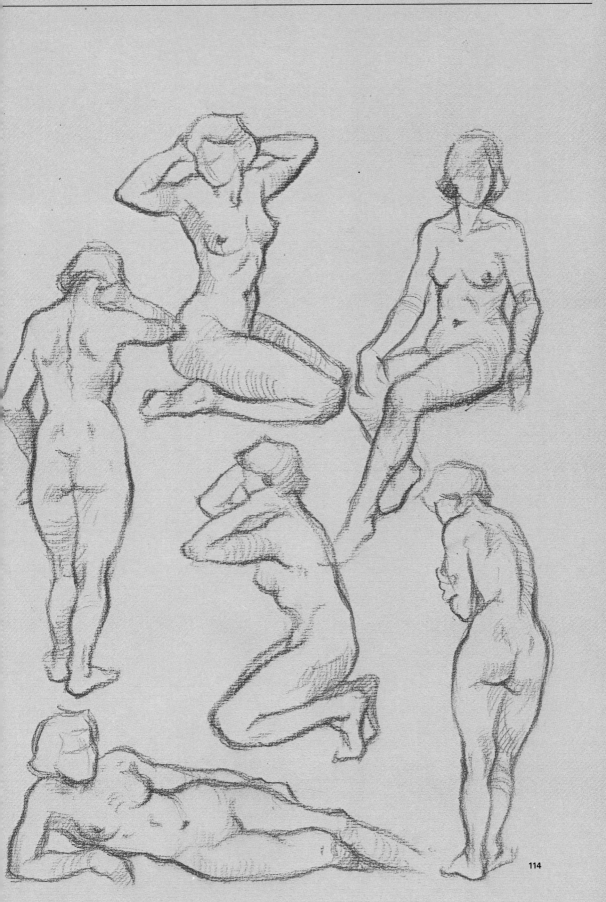

114

There is one more step, a very
important step, in the cycle of
basic lessons that you need to
draw and paint the human figure.
It's about lighting—its effects:
frontal or lateral; quality: direct
or diffuse; shade: natural,
projected, or chiaroscuro; and
tonal values: the capacity to see
and classify tones. Then, we'll
study a series of examples. We'll
finish off by discussing how
technique and medium help
create an original style.
Everything you need to know
about the art of painting the
human figure is discussed in this
chapter.

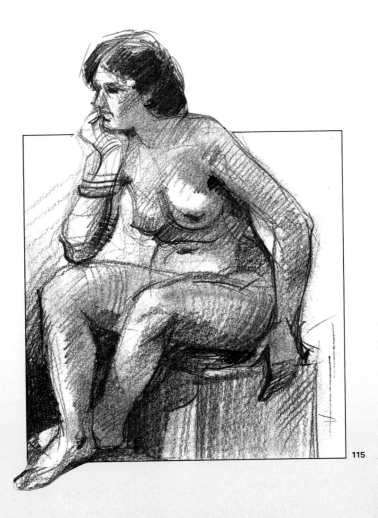

115

A GENERAL APPRAISAL OF THE HUMAN FIGURE

Light and shadow in the human figure

Light gives form to a body, creating shadows on the body itself and shadows projected from it. The light may be natural or artificial. It may fall on the model from the front or the side. Depending on its *quantity, quality*, and *direction*, it will create greater or lesser contrasts on the body, influencing the manner in which the work is executed as well as its final impact. You will also remember that areas of shadow are made up of various tones that determine the overall *chiaroscuro*, or light and shade effect. The major factors in that are *reflected light* and what we call in Spanish the *"joroba,"* or *dark ridge of shadow*, which is the darkest zone next to reflected light. To illustrate these characteristics, you can see in Figs. 116 to 119 the statue of Venus di Milo illuminated from different directions and the sculpture of Venus stooping illuminated with direct light (Fig. 120) from a spotlight—imitating sunlight— and receiving a dimmed, diffuse light (Fig. 121), like the light called "zenithal," coming from an elevated window or opening in the studio.

These general principles must be remembered and applied when studying and drawing the effects of light and shadow on the human figure. Indeed, the quantity, quality, and direction of the light will influence the way in which the artist sets about working, determining whether one should give a soft or hard treatment to a representation of the subject. The shaded parts of the drawing should incorporate subtle differences and qualities of tone (Fig. 122).

Are these general principles clear? They are? Good. Let's move on immediately to a practical study of shadow modeling in the human figure.

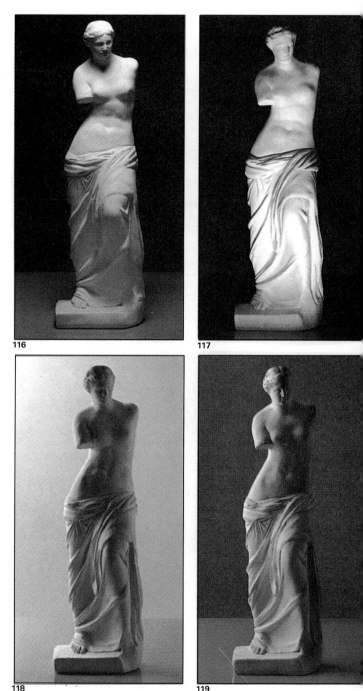

Figs. 116 to 119. Copy of the statue of Venus di Milo illuminated, respectively, from above (Fig. 116), from below (Fig. 117), from the back (Fig. 118), and from the side (Fig. 119). Also consider frontal lighting, as well as frontal-lateral lighting, the latter being the most *documentary*, that is, the one that best explains body forms.

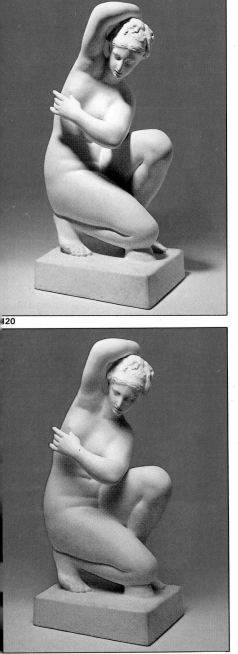

120

121

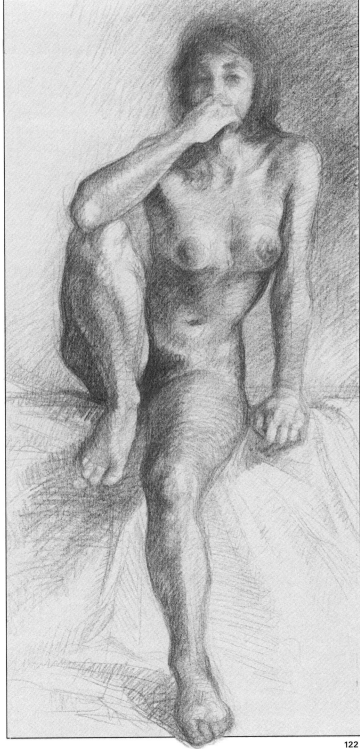

122

Figs. 120 and 121. Here are two examples of different qualities of light: top, direct light, which creates greater contrast; below, diffuse light, which is softer and more delicate.

Fig. 122. In this sanguine drawing of a nude by artist Miquel Ferrón, the model is illuminated by frontal-lateral lighting that gives a diffuse light and creates a harmonious softness.

Shading by planes or masses

Let's imagine that you have the model of Venus di Milo in front of you and that you have finished boxing up and outlining the structure. You are about to start modeling, boxing up, and drawing the effects of light and shadow. Remember that both operations—boxing with lines and with shadows—can and should be carried out simultaneously. However, we'll study them separately to make understanding them easier. The task before us is to render the whole range of values and tones offered by the model in a simple preliminary sketch.

The only way to accomplish this task is to see, or rather *know how to see*, where the tonal gradations that give shape to the figure begin and end. This means that we must momentarily disregard transitional or middle tones, seeing the model in stark terms of light and shadow, and conceive of these areas as planes, as if the figure were made up of a number of flat surfaces. Let's discuss this now with an illustration. In the figures we can see a graphic example of the idea outlined in the preceding paragraph. In Fig. 123, we have the model, exactly as you see it. In Fig. 124, the model is divided into masses, as it should be imagined without any tonal gradations; the areas of shadow are translated into planes. In Fig. 125, we have the model boxed in with shadows as a logical result of the previous stage. In Fig. 126, we see how the modeling is progressively built up on the basis of the earlier boxing. You may ask what you should do in order to visualize the model in imaginary terms and see its shadows translated into surfaces or planes. Doing so will enable you to box up and render its masses in a preliminary step to the modeling process. The answer is sim-

123

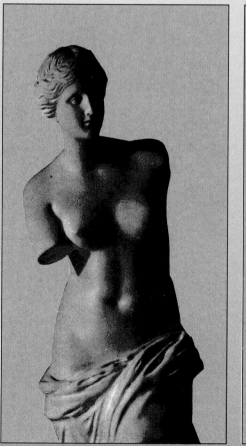
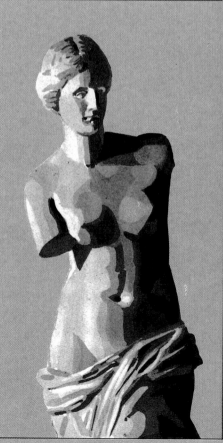

Figs. 123 to 126. In these images study the process used by the artist to interpret the shaded areas by creating planes or blocks. First, before beginning to draw, try to envision how the effects of light and shade, without transitional tones, can be defined as light and shadow planes in the model (Figs. 123 and 124). Then, project the shaded areas according to your vision (Fig. 125). Finally, develop your vision. Now you're ready to draw the model with all its values (Fig. 126).

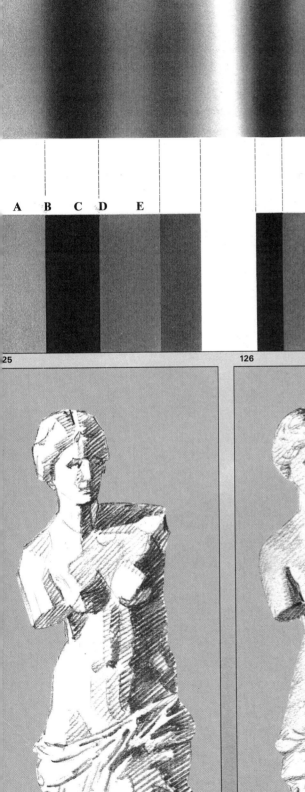

ple: Determine where the areas of light and shadow begin and end. In Fig. 127 we have drawn a tonal gradation as an example of this point. It is made up of a series of intermediate tones that merge gently into one another. Is it so difficult to transform these tones into well-defined planes? You need to establish the lines that separate the light area A from the darker area B, and this area from the still darker area C, or to see in D the hypothetical border between C and E. It's not that difficult, I can assure you.

127

25

126

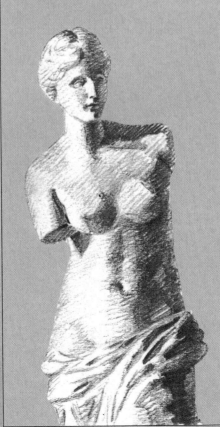

Fig. 127. This series of grays has a wide range of tonal values that go from black to very light gray. All the intermediary tones are shown on the top; and the synthesis of these, producing more specific tones and planes, is shown on the bottom.

Outlining areas of light and shadow

We should avoid falling into the trap of thinking that modeling with planes is merely a matter of mathematics or geometry, as if the human body were a kind of polyhedron! It isn't, of course; theory is one thing and practice is quite another. In practice, the transformation or synthesis of curved surfaces into masses or planes has its pros and cons. Let's take a look at this problem and study it through a series of images using the model illustrated in Fig. 130.

The old trick of squinting

You are already familiar with the squinting technique: Half-close your eyes, slightly contracting the muscles of the eyelids, so that your vision slips out of focus, thereby eliminating the soft, intermediate tones and subtle shades. This results in sharper contrast between light and shadow similar to the simplified image in which shadows were visualized as planes.

Remember to use this technique when you are looking at the model. Try to see and capture the specific areas of light and shadow through half-closed eyes.

As you can see from Fig. 132, there is often no hard and fast geometrical line separating a light from a darker area. Compare this finish with the one illustrated in Fig. 131.

Observe in this figure that there are areas in which circular strokes or spirals, or simple shaded areas, have been drawn to suggest a form's cylindrical or curved shape. You can see from this that one should not take the rule about shading by planes too literally. Rather, you should seek to know and apply the theory of dividing the model's soft and subtle range of shadows into more or less well-defined areas.

Figs. 128 to 130. The old trick of squinting your eyes allows you to see the model's tonal values and the effects of light and shade. As you can see in Fig 129, these are simplified in planes that absorb the small details of shape as well as tonal value.

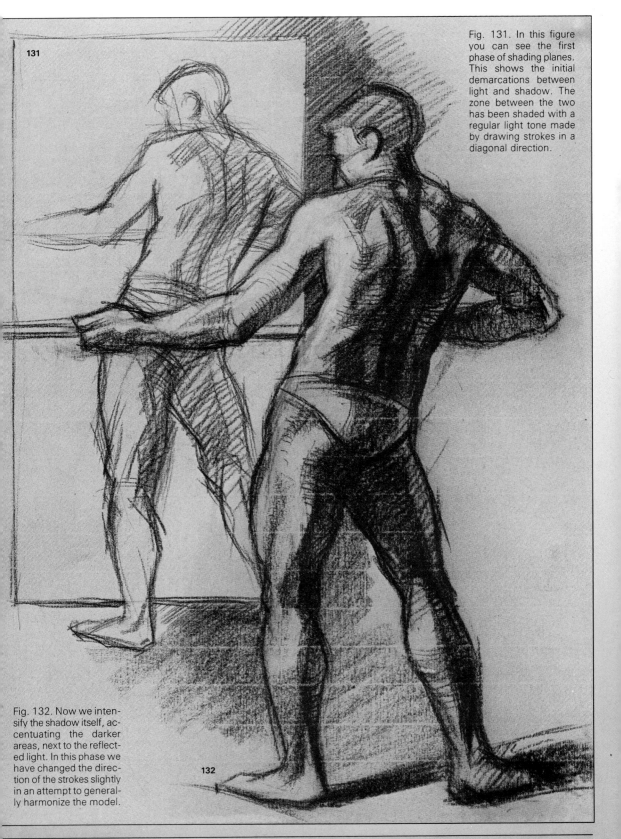

Fig. 131. In this figure you can see the first phase of shading planes. This shows the initial demarcations between light and shadow. The zone between the two has been shaded with a regular light tone made by drawing strokes in a diagonal direction.

Fig. 132. Now we intensify the shadow itself, accentuating the darker areas, next to the reflected light. In this phase we have changed the direction of the strokes slightly in an attempt to generally harmonize the model.

Academic modeling of the figure

Let's now proceed with modeling, studying the progressive development of values, contrast, and atmosphere in the *academic style*. Incidentally, the terms "academic drawing" or "academic painting" come from the technique used by artists during the 19th century, of whom Ingres was the most representative. They drew and painted with the utmost realism, coldly and precisely reproducing the forms and values of the model. Nowadays, such a style is only considered appropriate for academic studies or exercises. However, for the time being, this is the style we'll aim for, attempting to clarify with it the basic concepts of human figure modeling. That way, we'll acquire the necessary skill to find and develop our own individual style.

Let's revise the basic rules for creating a perfect, realistic or, in other words, academic model. Remember that *building value is a matter of comparing, observing, concentrating all one's attention on a given value, on a specific tone observed in the model, until it is engraved in one's memory, so that one can compare it with other tones.* The first rule is to *see and draw light,* analyzing and viewing the model as an amalgamation of surfaces sculpted by light and training our eye always to see tones instead of rigid outlines. Value and structure, harmonization and finish should be built up gradually, as you work simultaneously on the whole composition, *as if it were a photographic print being developed, with all its details gradually emerging at the same time.* Remember that value may be adjusted by studying and comparing the contrast between the various tones. Don't forget to use the law of *simultaneous contrasts* (Figs. 133 and 134), which states that "the darker the tone surrounding a white area, the whiter that white area will appear." Consider also the possibility of *intentional contrasts,* that is, intensifying a tone that borders on a relatively light one, so that either or both are thrown into relief. Finally, do not overlook the possibility of creating atmosphere, suggesting ambience, softening contours, sharpening the focus on the foreground, and vaguely blurring the background.

Intensify the shading slightly on the head, the arms, and the legs

In my experience of drawing nude studies from life, the range of values on the head and the extremities is richer than on the trunk. Indeed, with only a few rare exceptions, the head and the hands are always just a shade darker than the rest of the body. Note that this slight darkening effect is progressive, from the arm down to the hand and from the knee to the foot. Generally, this is a logical, natural phenomenon, since the forearms and the hands, like the legs and the feet, together with the head, are the parts of the body most often exposed to the air and the sun.

Summing up the lessons detailed on the previous pages, we can observe this process in a drawing of a female figure

Figs. 133 and 134. T■ *law of simultaneous co■ trast* tells us that "t■ darker an area surroun■ ing a white area, t■ whiter the white area w■ appear." This law is illu■ trated in the figures b■ low. Compare a whi■ square on a light gr■ background with t■ same white square on ■ black background. It a■ pears as though the la■ ter is whiter than t■ former. We can also a■ ply this law to the co■ trast in a picture with ■ figure. It allows us to cr■ ate lights in white are■ simply by darkening t■ tones around them.

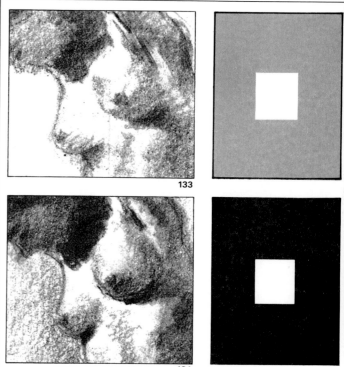

133

134

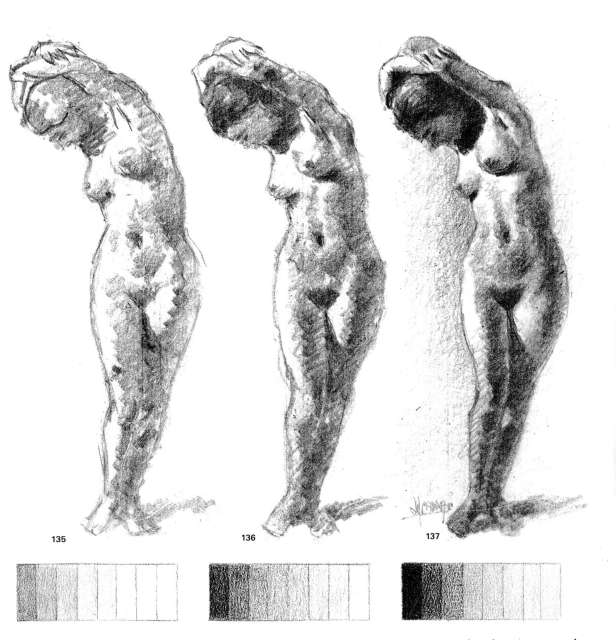

135 136 137

Figs. 135 to 137. This shows a step-by-step drawing of a female nude. The artist used a B lead pencil on large-size Canson paper.

(Figs. 135 to 137). Note the following three factors: In the first stage (Fig. 135), the figure already has grays and gradations with hardly any reference lines. The first factor to note is that contours are not created by lines, but come from the body's values and tones. So do not create contours with lines; do it with tones. A second factor to consider is the necessity of advancing the picture progressively, all together—that is, not in separate parts, but all at once (Fig. 136). The third factor is that working in a progressive fashion will allow you to create tonal values going from *more to less* as you adjust and perfect the volume or quality of the effects of light and shade (Fig. 137). Note this priority:
Draw and add value progressively.

A gallery of examples

Fig. 138. As a graphic summary of the lessons that began on page 62, look at these male nudes by Mariano Fortuny. You can appreciate the muscular complexity these images have acquired, including the position and form of each muscle. These drawings provide an excellent representation of a living human body.

138

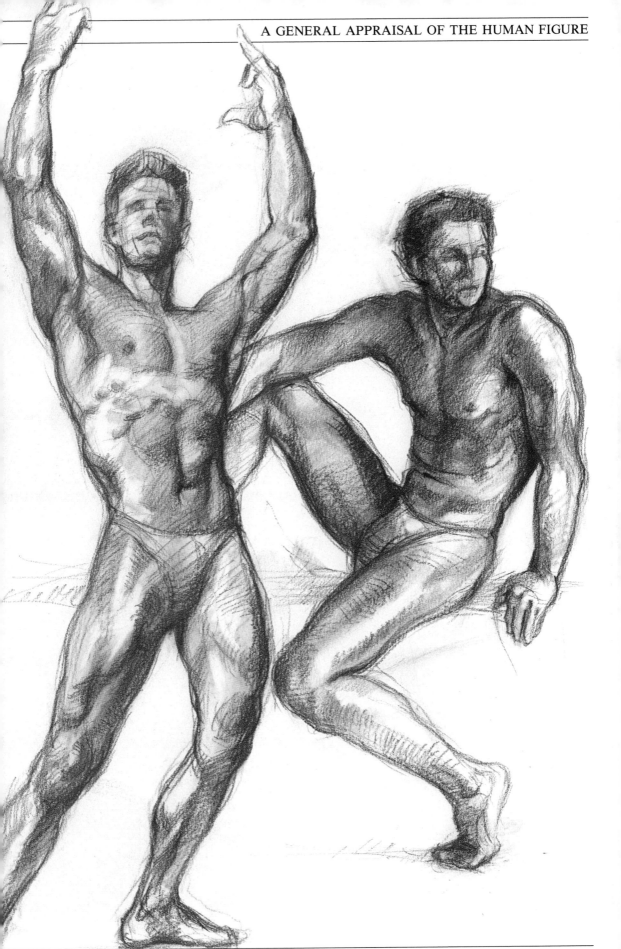

Fig. 139. Mariano Fortuny (1838-1874), *Discobolus from the Front Side*, Fortuny Collection of the Royal Academy of Fine Arts of Sant Jordi, Barcelona. In this work drawn with pen on pink paper, artist Mariano Fortuny shows us an indepth study of the human body's anatomy in the academic style popular in the middle of the last century.

Fig. 140. Mariano Fortuny, *The Archer*, charcoal, Fortuny Collection of the Royal Academy of Fine Arts of Sant Jordi, Barcelona.

139

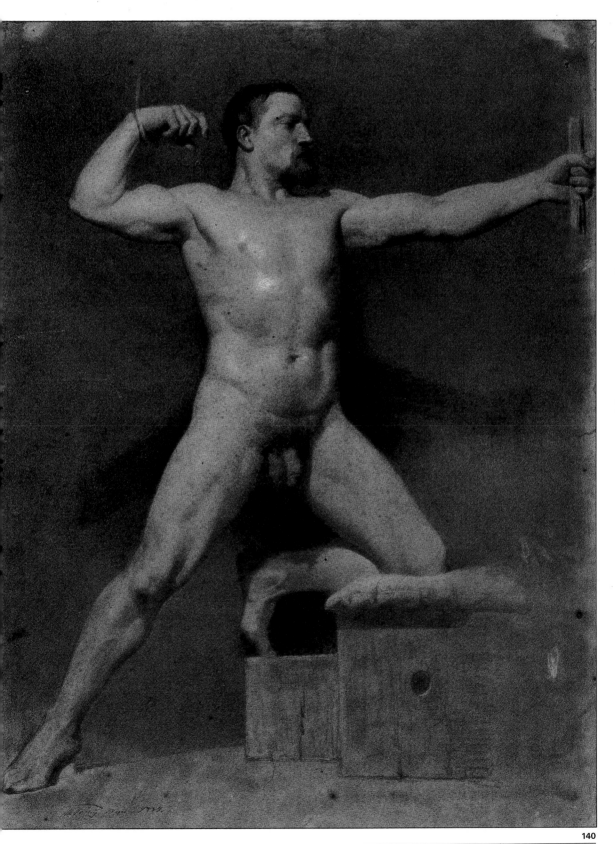

140

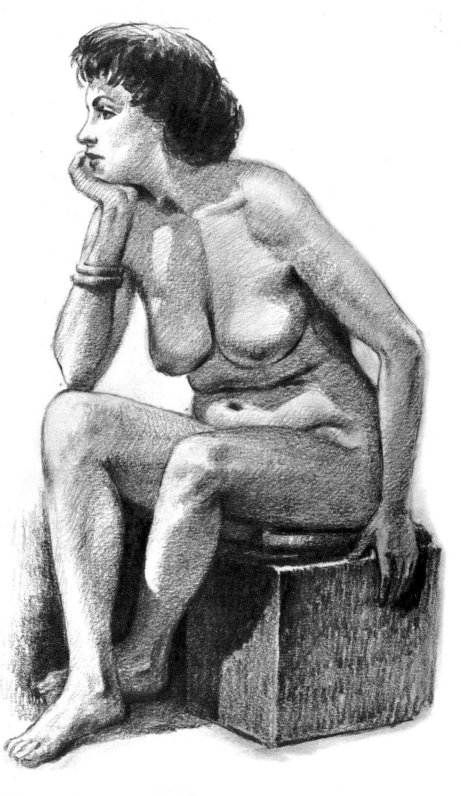

Fig. 141. This drawing was done with a live model. Lead pencils of HB, 2B, and 6B gradations were used on large-size Canson paper. The HB was used for the initial structure, the 2B for the drawing and general tonal values, and the 6B for intensification of the darkest areas in the final finishing.

Fig. 142. Miquel Ferrón did these studies of the female nude using the drawing technique known as ''à trois crayons.'' That's what the French called it in the time of Boucher and Watteau, when drawing on cream-colored paper with charcoal, sanguine, and chalk was very much in fashion. Ferrón's drawing is a good example of this technique.

141

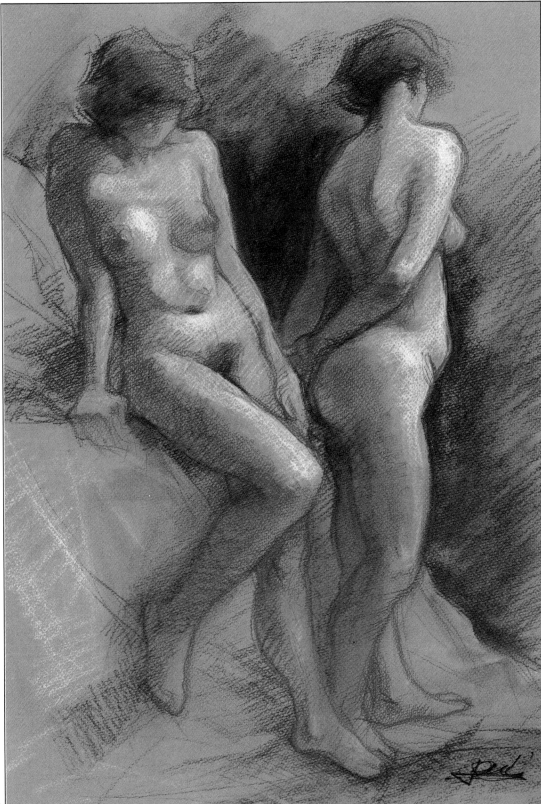

Drawing in your own style

As you well know, *style is the artist's characteristics that appear in his works*. In order to render these characteristics the artist interprets the model in a personal way, drawing the form and massing it according to his own way of living and thinking, his experience, his spirits, and even according to the styles around him. To the personal interpretation of form and massing, the artist adds the way of executing the work he prefers the most, depending always on a precise technique and the medium he is going to use. Therefore, *form, massing,* and *execution* are the three main factors the artist can play with to render his own style. We're going to study briefly the possibilities they offer.

Form

Among all the factors, form is the one that can be interpreted most conventionally. You can lengthen it, widen it, make it harder or softer, idealize it, but regardless, working with this factor invariably means changing the model's normal appearance, distorting it, which may result in ill-conceived originality, or a style that defies or frustrates the viewer, replacing contemplation with uneasy bewilderment. By all means, stylize your forms, but don't run before you can walk. Don't distort forms until you really need to. You'll acquire this technique only after you have fully mastered the academic style of drawing, after drawing so many normal figures that you'll experience an overwhelming need to find new forms of artistic expression. Follow, once again, the example set by the great masters, for example, El Greco, the first artist to become famous for his distortion and stylization of the human figure. He certainly didn't use this technique from the beginning. We have only to compare one of his early paintings of the Toledo period, *The Martyrdom of Saint Maurice*, with any of his later works, for example, *The Baptism of Christ*, to see that his fantastic and

magnificent distortions were not the fruit of a single day's work, but the result of a relentless, progressive study of form.

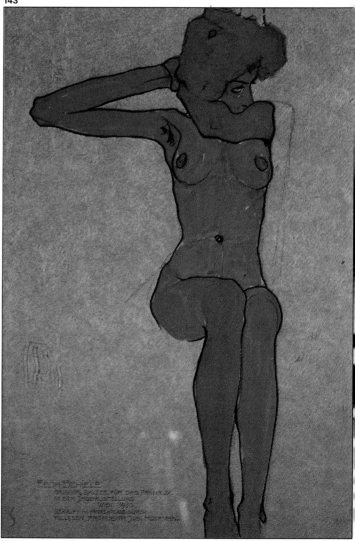

143

Fig. 143. Egon Schiele (1890-1918), *Sitting Nude*, Historisches Museum, Vienna. The ill-fated Schiele developed a very personal style which is reflected in this drawing in black pencil and watercolor. Distortion of form is very evident.

Massing

Massing, like form, may be perfectly normal in the model, that is, in a photographic, academic sense; but as an artist creating your own style, you may see and interpret it in your own way, according to your temperament, and depending on the meaning and message you wish to give to the work. This also applies to *contrast*. You may choose to make it sharper or starker, treating the figure as a scenario for black-and-white interplay. Alternately, you can tone down the contrasts, giving your work an extremely delicate treatment. You can also modify the *atmosphere*, bringing in your own personal style, or even dispense entirely with this factor, drawing with great precision and definition in a hard, steely, trenchant style. On the other hand, you can exaggerate atmosphere, attenuating the forms, drawing them as if seen through a frosted glass (Figs. 144 and 145).

145

144

Figs. 144 and 145. Here are two interpretations of a model with formal resolution, that is, without deformations. In the standing figure, I have tried to accentuate the contrast by eliminating light and shade transitions as much as possible. In the seated figure, I have softened the maximum effects of light and shade, as if we were looking through a ground glass.

Execution: technique and medium

Execution is influenced, primarily, by technique, or manner of drawing, shading, blending, and so on, and secondly, by the medium the artist has chosen, be it lead pencil, charcoal, sanguine, or ink (using a quill, a brush, or a reed). Whatever the medium, the execution or method the artist employs is a vital factor in determining style. It is the hallmark, the distinguishing feature of the brush stroke or the line or the combination, for example, of a rough paper with a soft pencil, producing a tonal gradation with short, hard strokes made by rubbing the blunt or sharpened tip of the pencil over the paper.

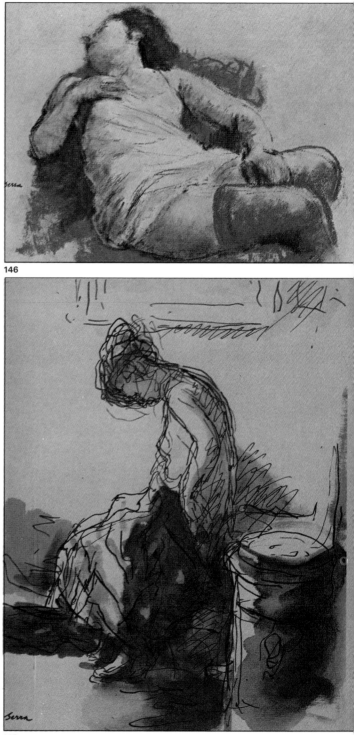

146

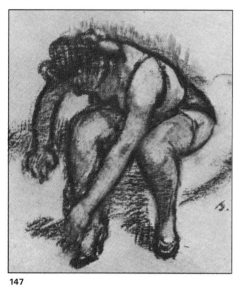

147

On these pages, you can see some pictures by the artist Francesc Serra showing different mediums and techniques (Figs. 146 to 150).

148

A gallery of examples

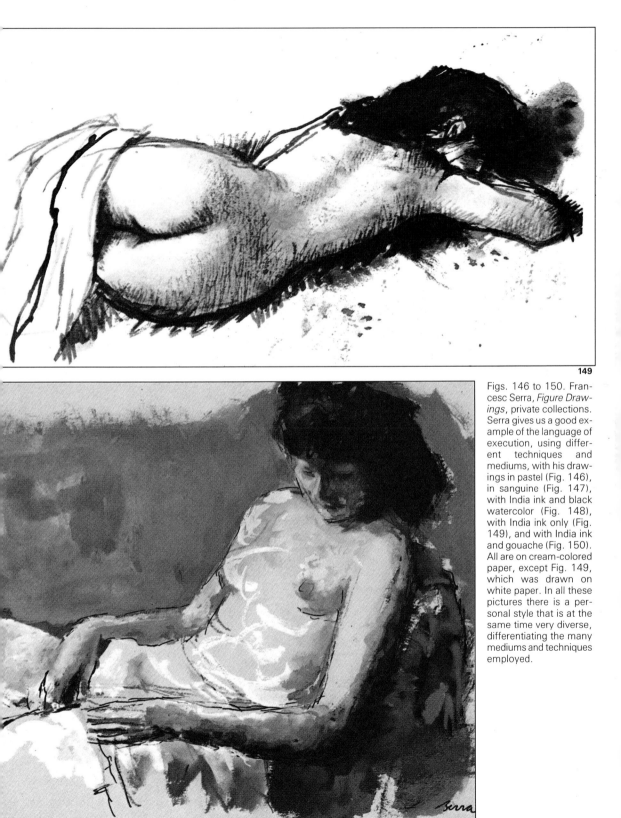

149

150

Figs. 146 to 150. Francesc Serra, *Figure Drawings*, private collections. Serra gives us a good example of the language of execution, using different techniques and mediums, with his drawings in pastel (Fig. 146), in sanguine (Fig. 147), with India ink and black watercolor (Fig. 148), with India ink only (Fig. 149), and with India ink and gouache (Fig. 150). All are on cream-colored paper, except Fig. 149, which was drawn on white paper. In all these pictures there is a personal style that is at the same time very diverse, differentiating the many mediums and techniques employed.

Drawing the human figure: a daily exercise

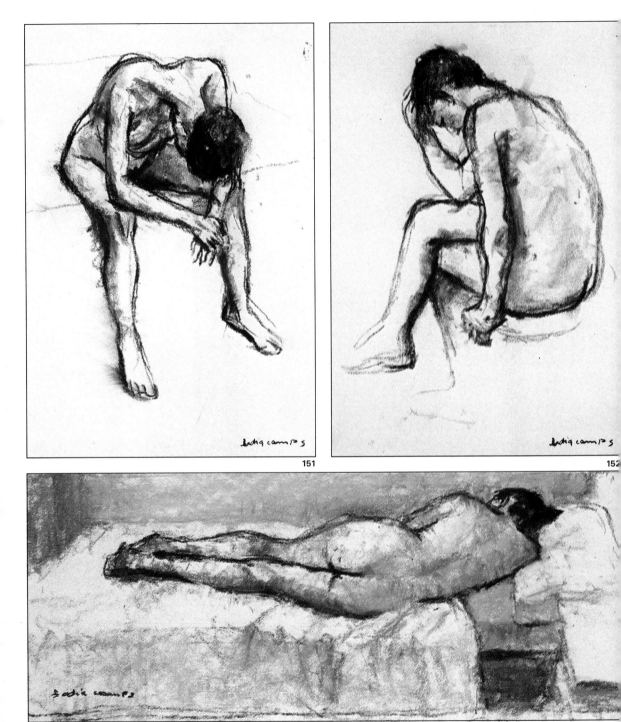

Figs. 151 to 156. Drawings and oil paintings by the artist Badia Camps, celebrated for his *intimate painting* and female figure paintings. According to what he himself says, he is able to create color range, contrast, tonal value, and harmony in his paintings all thanks to the perfection and absolute domination of the art of drawing.

A gallery of examples

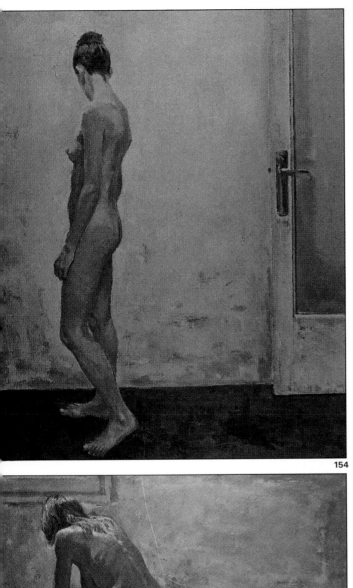

154

156

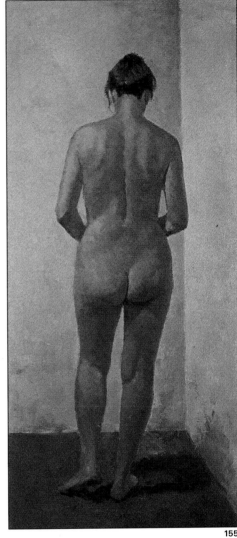

155

Badia Camps, professor of drawing and renowned oil painter of female figures, shows us some of his latest paintings, along with some of his many drawings and notes on the figure (Figs. 151 to 156). "Drawing figures is something I make myself do almost every day," says Camps. "Not only does it help me perfect my work, but it also helps me find ideas and compositions for new paintings. Tell your readers that constant practice of drawing separate from painting allows you to paint—mixing and harmonizing colors—without the need to draw what you paint. Tell them that only by drawing many figures many times is it possible to reach a high standard in the art of painting figures."

Yes, the parts of the body deserve to be studied separately; the trunk and the extremities—the arms, legs, feet—have all been studied closely by artists past and present. Leonardo da Vinci, Michelangelo, Raphael, Dürer, all the Renaissance artists, and Rembrandt, Rubens, Delacroix, and the Impressionists have all spent hours drawing torsos. Who does not remember Michelangelo's torsos? Or legs, arms, hands? Hands are probably the most difficult part of the human body to draw, as we'll see in the next pages. And clothes, another subject in hundreds of pictures in museums all over the world. Drawing clothing is a theme that will also be discussed in the following pages, a subject that requires a lot of practical study, a topic to be read about with pencil and paper in hand.

157

A DETAILED STUDY
OF THE PARTS
OF
THE HUMAN BODY

According to Michelangelo, the most important part of the human body is the torso

Indeed. Michelangelo attached great importance to drawing the torso. "From studying a large number of his drawings," Professor Stratz tells us, "it is obvious that he began his drawings not with the head, but with the trunk. In his figure studies, the hands, feet, and head are often merely indicated by a few faint strokes, whereas the trunk is minutely drawn in the greatest detail."

Michelangelo's fondness for this part of the body is easy to understand when we consider that his overriding interest as a student of anatomy was in *the origins of movement*, that is, in the torso. For him, the most important parts were the muscles in the trunk and the limbs, which twist, bend, and stretch. The *moving parts*, however, the head, the hands, and the feet, were only of secondary interest.

Your own experience will bear that out. When the torso is properly structured and modeled, the other parts of the body can be drawn easily. You should devote a good deal of time to studying the torso. Draw it from the front, in profile, bending forward, backward, and sideways from the waist, in a sitting position, and so forth. Use yourself as a model in front of a mirror, or ask someone you know to pose for you.

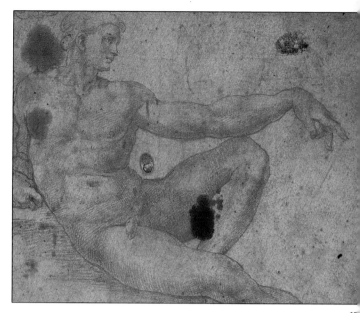

15

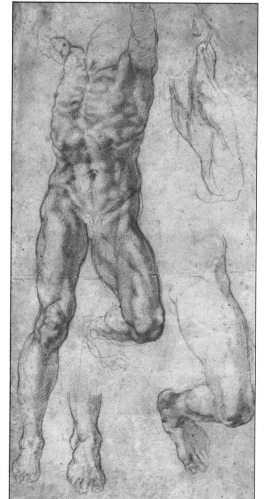

Figs. 158 and 159. Michelangelo (1475-1564), *Study for Adam* and *Four Studies of a Crucified Man*, sanguine drawings, British Museum, London. These studies of torsos, legs, feet, and hands made by the great master of the Sistine Chapel are real proof of the need to study parts of the human body.

159

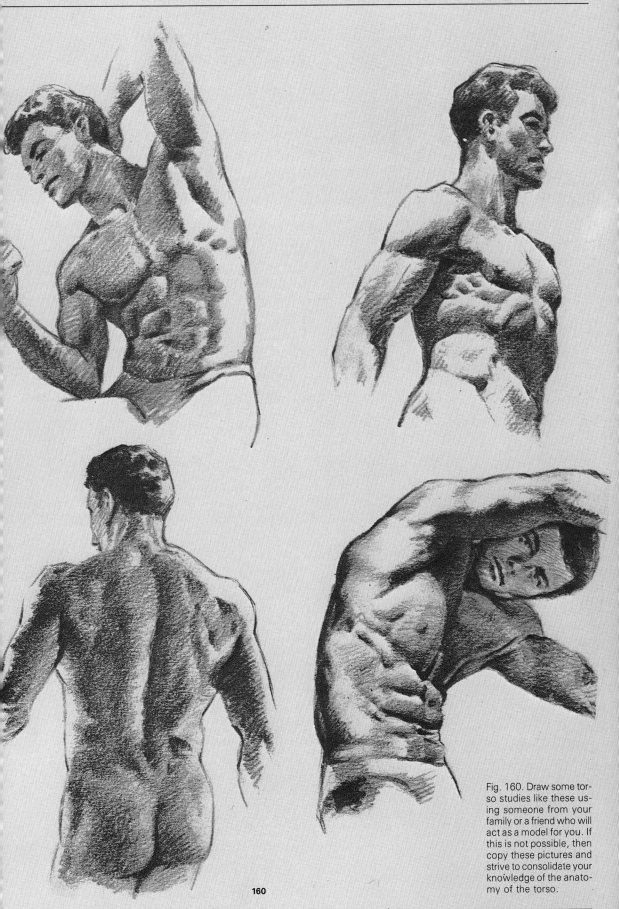

Fig. 160. Draw some torso studies like these using someone from your family or a friend who will act as a model for you. If this is not possible, then copy these pictures and strive to consolidate your knowledge of the anatomy of the torso.

160

Arms and legs, four muscular cylinders

Figs. 161 and 162. Note in these studies of arms and legs the importance of defining the form using strokes. When drawing with a lead pencil, charcoal, or sanguine, the strokes must be directed diagonally, but when we draw cylindrical shapes such as arms and legs, we must follow the curve of the forms with circular strokes to better represent the structure of the model. Practice drawing arms and legs using yourself as the model.

The basic concept of "the human body as a group of cylindrical forms" is particularly appropriate to the arms and the legs. The arms and the legs are precisely that, and then the corresponding mass of the underlying muscles and bones is added on.

It is necessary to be familiar with this muscular mass in order to shape the cylinders accordingly. Observe my own studies of the arms and the legs, carefully noting in each the position and shape of the muscles (Figs. 161 and 162). Notice one very important detail in connection with modeling these

parts, which is also relevant to modeling the trunk and to all the parts that are essentially cylindrical:
The strokes should follow the curve of the cylinder.
Pay great attention to this detail. Never draw the shadows on a cylindrical form, for example, on an arm or a leg, using vertical strokes along the length of the limb, as if you were drawing slats on a barrel. If you do, the limb will end up looking as if they were precisely that—barrels. Always use spiraling strokes *following the curve of the cylinder*. Similarly, when you blend the

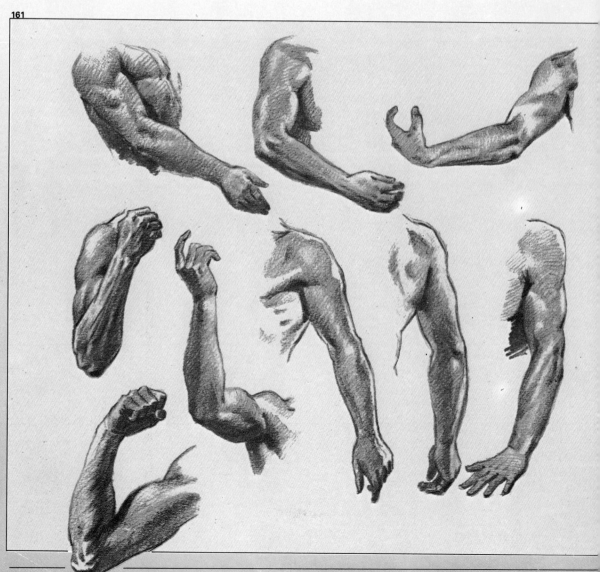

161

The complex shape of the feet

trokes, use your fingers or a stump in circular motion. Finally, remember that even boxing or shading can be executed with oblique strokes, but never, repeat, with vertical strokes.

Now you really can use yourself as a model to draw your own feet. Do it when you have a spare moment. Take off your shoes, and with the help of a mirror placed almost vertically against a support on the floor, look at them, study them, and draw them. Their shape is rather complex, especially if you try to represent them without paying attention to the boxing up and structuring stages.

Study the adjoining illustrations; some of them show my own feet. These include illustrations of bare feet of both men and women, as well as their shoes.

162

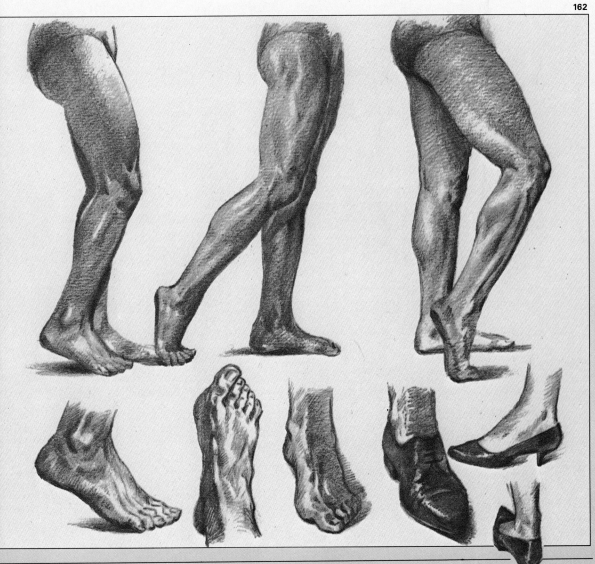

The hands, the most complex part of the human body

Of all the parts of the human body, the hand is capable of the widest range of positions. It can be viewed from above, from below, from the front, from the side, with the palm open or closed, with the fingers in this position or that—in an almost infinite number of positions.

It is certainly no easy matter to draw the hands, and perhaps because of their inherently complicated form and as a feat of virtuosity, many artists have chosen the hands as focal points for their pictures.

First, we'll study the ideal dimensions of the hand (Fig. 163), bearing in mind that its total length is equal to two times its width, and the palm, or lower part of the hand, is shaped like a square. Check that the length of the middle finger is equal to half the total length of the hand (A) and that the index and ring fingers are slightly shorter, with the tips of these fingers reaching the base of the nail of the middle finger (B). Notice that the tip of the little finger is level with the upper joint of the ring finger (C). Observe also

how the tip of the thumb forms an almost perfect arc with the central joints of the other fingers.

Also in Fig. 163, you can study the form and dimensions of the hand seen in profile. In this position, the thumb is almost face on, while when the hand is seen from the front, the thumb is in profile. Study in this same figure the length, form, and position of the fold at the inner base of the thumb (D); this is crucial for the correct structuring of this part of the hand. Compare the hands in this figure, observing the variation in the above-mentioned fold when the thumb is shown extended and separated from the hand, forming an angle of 90 degrees (E).

Study the shape of the cupped hand, paying close attention to the resulting creases and fleshy mounds. Study all its aspects through constant, direct observation of your own hand.

163

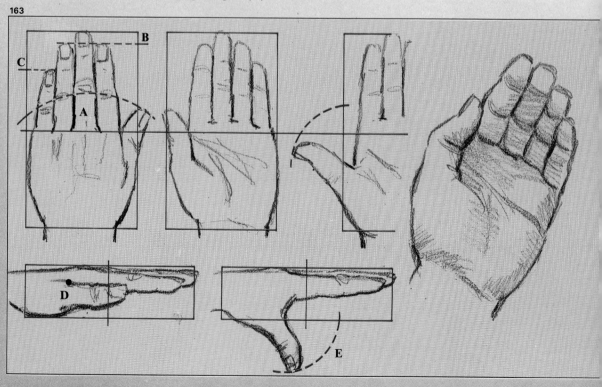

Anatomy of the hand

Now study the skeleton of the hand. It provides the key to the hand's external structure, the bones often clearly visible just beneath the skin (Fig. 164). Bear in mind these two fundamental points concerning the skeleton of the hand:

1. *The bones of the fingers are, in fact, a prolongation of the metacarpals.*

2. *The joints of the fingers can be joined by a series of parallel curved lines.*

The first point teaches us that the position of the knuckles beyond the fingers, whether the hand is closed or half-closed, must always bear a relation to that of the knuckles on the fingers.

Look at your own hand; open it, close it, move it. You will see that the knuckles on the fist and the fingers are always in a straight line.

The second point needs no explanation, although a few illustrations will help show that this parallel relationship is maintained at all times, whether the hand is totally or partially closed (Fig. 165).

Use these principles to achieve good results in your drawings of the hand. Above all, be meticulous in calculating dimensions and proportions, remembering that this method is the only true guarantee of success. Draw a variety of hands, especially your own left hand in various positions while you work with your right hand. Use a mirror to obtain a greater number of different positions.

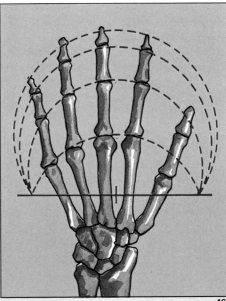

Fig. 164. The morphology of the hand is determined to a great extent by the skeleton: The joints and knuckles of the fingers form a series of symmetrical curves parallel to each other.

Fig. 165. Whatever the hand's position, the knuckles above the fingers are always parallel with the finger knuckles and form symmetrical curves, as illustrated in Fig. 164.

164

165

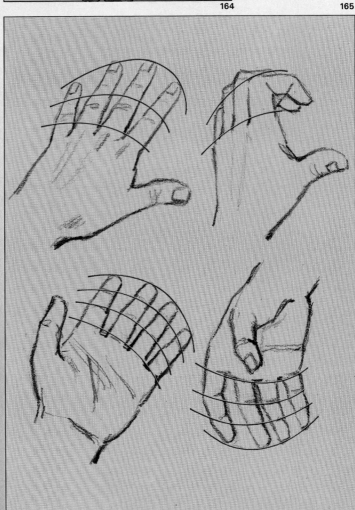

Draw your own hands

Fig. 166. Draw your hands, first, your left hand while you draw with your right, or vice-versa if you are left-handed. Then, use a mirror to draw the other hand. Get used to the idea of putting the mirror on the table where you draw to discover the different poses of the hands. It is a surprising and fun way to learn.

Finally, observe how, when it came to modeling the hand, I used a circular motion for blending with my pencil, fingers, and stumps to create the cylindrical forms. Note also how I created volume by using dark ridges of shadow and highlights. (Fig. 166).

166

Fabrics and clothing

Fig. 167. The fabric on the left is a sheet; on the right is a blanket. We recommend you practice drawing different kinds of fabrics in order to capture their texture.

Whether drawing from a model, or more especially when drawing from memory, you will often have to create the appearance of garments worn by one or more figures, with all the attendant problems of texture, folds, creases, including the many ways in which fabric adapts to the body. It is quite normal, for example, for the artist to be drawing or painting a portrait and one day observe some specific folds on the sleeve of the model, which, on the following day or at a later sitting, take on a different form. That forces the artist to work from memory and to rely on his or her understanding of fabrics and clothing to solve the problem.

Some practical exercises for a general study of fabric and clothing

Our study of fabric and clothing consists of exercises in drawing different types of cloth, arranged in various ways—draped over a table or a chair or on a wall.

To draw these fabrics, you'll have to deal with the formidable problem of volume and massing. This problem may not be new, but it is nonetheless interesting. It will also give you the opportunity to study the appearance and texture of each kind of fabric, faithfully reproducing its features so that by merely glancing at the sketch, it is possible to tell whether the fabric is cotton, coarse wool, smooth silk, or any other cloth.

Look at Fig. 167. There I have drawn a sheet in lead-pencil and a blanket in charcoal.

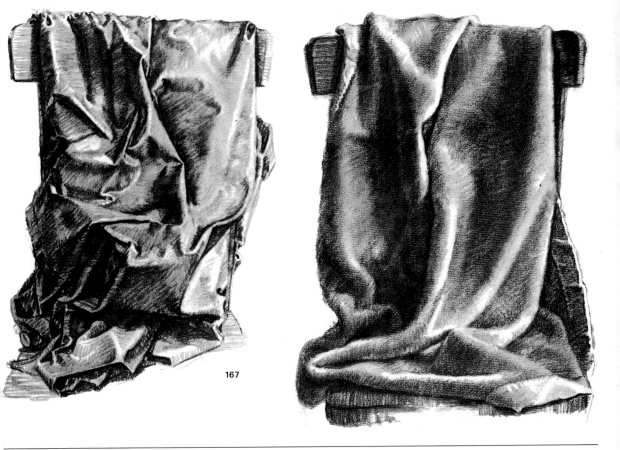

167

Practical exercises in fabrics and clothing

Figs. 168 to 170. Make a model by draping a sheet according to the instructions in these figures.

Fig. 171. You can see in these images (A) the initial resolution and (B) the finished picture of the sheet.

Prepare the chair or table over which you intend to drape the model; decide on the best lighting. Finally, bear in mind the following instructions:

1. *Work preferably with artificial light and always from a frontal-lateral position in order to achieve maximum relief.*
2. *As far as possible, choose radically different types of cloth, such as cotton sheet, thick, deep-pile woolen blanket, a piece of satin, silk, or shiny cloth.*
3. *Make sure these cloths have been ironed.*

Now let's *learn by doing it.*

Look for a piece of white sheet about 12 × 20 in. (30 × 50 cm), iron it, and hang it up with two drawing pins on a white wall (Fig. 168). Fold the sheet, pierce it at point A with a third drawing pin (Fig. 169), and move that drawing pin to point B, sticking it into the wall (Fig. 170) so that you have a series of creases, as seen in Fig. 171. Now you have a model that I have drawn following the same process.

First, we need to know what the usual folds and creases of a given garment look like, while trying to simplify these forms as much as possible. Let's take the example of the creases found in a sleeve of a man's jacket when the arm is bent at the elbow. If we refer to the

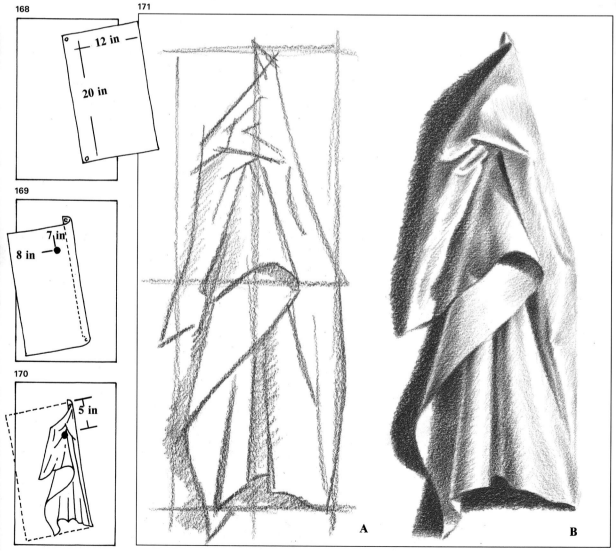

168

12 in

20 in

169

7 in

8 in

170

5 in

A

B

A study of folds and creases

172

173

models in Figs. 172 A and 173 A, we might come to the conclusion that it's a terrible ordeal to remember that vast array of intricate folds and creases. However, let's interpret them, picking out only the essential lines and creases needed to express the flexed arm. Figures 172 B and 173 B illustrate this simplified formula. As you can see, the intricate pattern has been reduced to a few succinct strokes, which, nevertheless, are sufficient to express and convey the shape of this part of the model.

To this simplified formula, we can add any number of folds and creases, but no superfluous detail should obscure the basic pattern. The main thing is to capture the nature and dynamics of the folds, bearing in mind that these are the effect of a given cause.

When you bend your arm, the cloth of the sleeve will inevitably become wrinkled, forming creases in the crook of the arm. The elbow will also pull and tug at the cloth around the inset of the sleeve, thus producing transverse folds on the arm and forearm. At the same time, the opening at the cuff will be seen at an oblique angle, slanting backward toward the elbow (Fig. 174). A similar effect is produced in the trouser leg when the leg is bent.

Figs. 172 and 173. To be able to draw a dressed figure from memory or a picture, it is often necessary to complete the drawing or painting in more than one session. Of course, creases in clothes change from one day to the next. Try to simplify and synthesize the creases to get around this problem, as you can see in these illustrations.

No effect without a cause

When you extend your arm or leg, the cloth is stretched the length of the limb, and inevitably transverse folds appear in it, in the opposite direction to the movement of the limb (Fig. 175). This same figure shows how the jacket is pulled out of shape when the arm is raised: One lapel is raised higher than the other, and if the jacket is buttoned, a large fold will appear at the waist, as a result of *being tugged upward by the sleeve* as the arm is raised.

Finally, when you bend forward from the waist, your clothes tug at the back and fall loose at the front, forming horizontal folds at the waist and both upward and downward diagonal folds at the sides, which tend to converge toward the middle (Fig. 176).

Draping the figure yourself

These observations concerning the movement and tension of the fabric— as well as the proportions of the garment—are sometimes more easily understood by referring back to the nude figure. It's an old trick, used by many artists when they have to draw figures from memory. Keep it in mind. All you have to do is lightly sketch the nude figure (Fig. 177), and then draw garments on it (Fig. 178). In this way, you'll have a better idea of the folds and creases caused by the movement of the limbs.

Figs. 174 to 176. There is no effect without a cause. When you fold your arm or leg, stretch or bend your arm, a series of creases are produced in your clothes, in sleeves and trouser legs. By analyzing these causes, it's easy to understand and draw the effects, whether you are drawing from memory or from life.

Figs. 177 and 178. To draw a picture of a dressed figure, start from a sketch of the nude figure. This manner of working is used very often. It helps the artist adapt clothes to the body, allowing a more proportional study and a more precise representation of creases and folds.

Draping the figure yourself

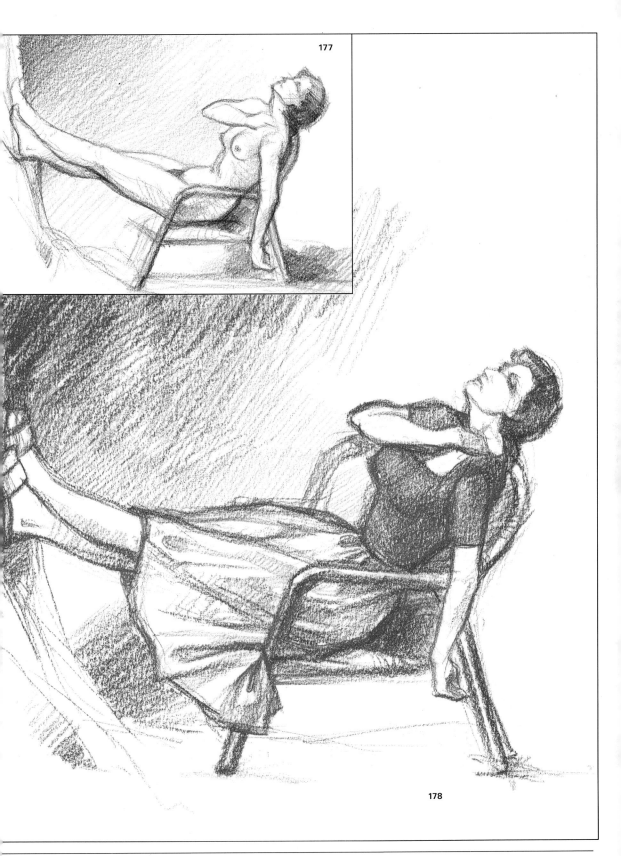

177

178

This final chapter is
devoted to practicing
drawing the human
figure step by step.
First we will develop
sketches of a dressed
male figure and a
nude male figure,
then will execute two
drawings of a nude
female figure. There
is additional
instruction in
working with
different mediums,
techniques, and paper
surfaces.

179

A PRACTICAL EXERCISE IN DRAWING THE HUMAN FIGURE

Charcoal sketch of a dressed figure

As a summary of what has been explained on the previous pages, we are going to draw several figures from the live model, using different media and techniques in every case. Two of the drawings are sketches and two are finished drawings.

In the first sketch I am going to draw a clothed male figure. Study the model's pose in Figs. 181 and 182, noting the slight differences in the position of the head, body, and hands. The pose in Fig. 182 is an improvement. This sketch was carried out in charcoal on a sheet of white Ingres paper measuring 29½ × 43¼ in. (75 × 110 cm). The gradated tones and shadows were achieved by holding the charcoal flat and using the end to make large strokes. No stumping was necessary.

Fig. 180. José M. Parramón, the author, drawing one of the sketches in this book.

Figs. 181 and 182. Drawing directly from the model makes it possible to improve the original pose by changing the position of the head, the hands, and so on.

181

182

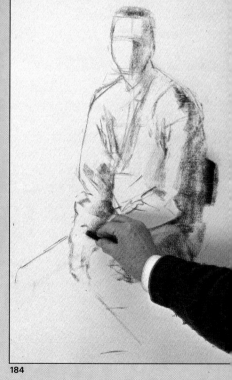

184

183

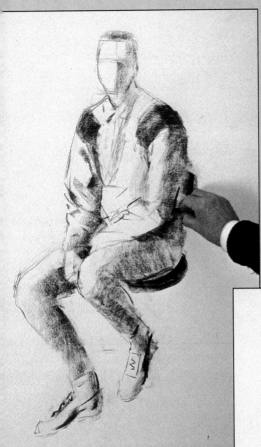

186

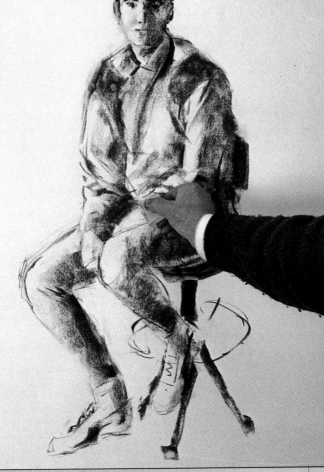

187

You can create the variety of tones seen here by increasing pressure in drawing the dark areas and decreasing it for the light areas.

The development of this sketch shows linear resolution. The shapes and the play of light and shadow were stated from the very beginning. Everything was drawn at once, without any details.

Figs. 183 to 187. Charcoal is a quick medium that allows you to draw, value, and finish a sketch in a very short time. The artist must take advantage of this quality to solve the shapes and outlines of the model, as well as the lights, darks, shadows, and variations in tone from the moment the drawing begins, disregarding the little details.

Charcoal sketch of a nude figure

We are going to sketch a nude male figure with charcoal, now using stumping with the fingers. We will also be using the kneadable eraser to create lights, whites, and reflections.

Note how, as always, I have blocked in some strokes to indicate the eight-head canon for the human figure (fig. 189). First I draw a linear sketch of the figure, then I establish all the shapes, lights, and shadows of the model. In the third step of this sketch (Fig. 192), look at the grayish tone that "stains" some light areas of the model. Then look at the results of using an eraser in Figs. 193 and 194. The highlighted areas were created by "drawing" with the eraser to achieve more effective contrast.

188

Figs. 188 and 189. The pose th model adopts here makes it po sible to study his figure in terms the eight-head canon.

Fig. 190. Now the technique to d velop is the charcoal paintin blending with the fingers. Th technique allows the artist to d velop the areas of light and shad

Figs. 191 to 194. From the roug sketch of fig. 189, the drawing d velops progressively and quickl Drawing and modeling with th charcoal, along with the finge and the eraser, lead to the final ou come that you see in fig. 194.

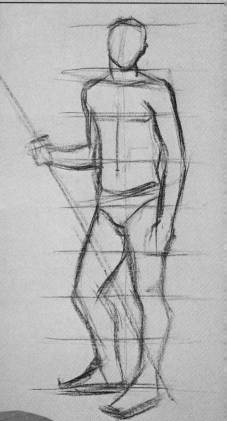

18

190

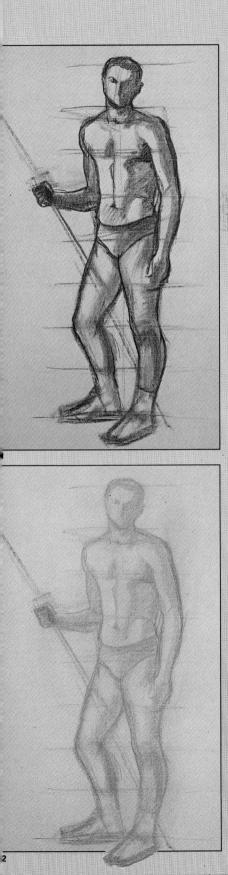

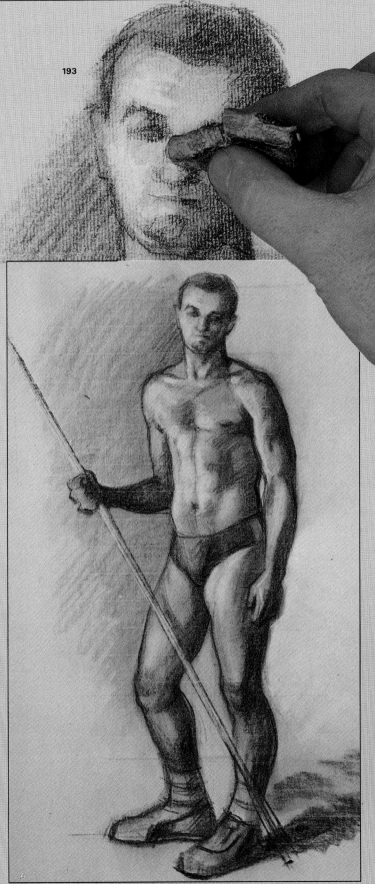

193

194

Lead pencil sketch of a female nude

Now I am drawing a female nude as a finished drawing, using a sheet of fine-grained Schoeller paper. I am using an HB lead pencil for the initial sketch and two all-lead pencils, 3B and 6B, to create the shadows of the model. I will use the technique of stumping with the fingers along with a very thin stump for the little details. I will use also a kneadable eraser to open up lights and highlights.

As you can see in Figs. 196 and 197, the model's pose can be summarized in a triangle and is determined by the height of four heads.

First, I drew the linear sketch with the HB pencil. Then, I valued the drawing with the 3B all-lead pencil using a regular, steady stroke, without stumping. Next, I began stumping with my fingers, establishing values and darkening some areas with the 3B and 6B pencils as well. I continued stumping and finishing the little details, "drawing" with the eraser to sharpen and lighten some tones and open up whites and highlights. The final outcome (Fig. 204) shows the extraordinary artistic possibilities of the lead pencil.

196

197

195

198

Fig. 195. These are th materials I have used t do this drawing: an H lead pencil for the initi sketch, two all-lead per cils (3B and 6B), a thi stump to work on sma areas, and a kneadabl eraser.

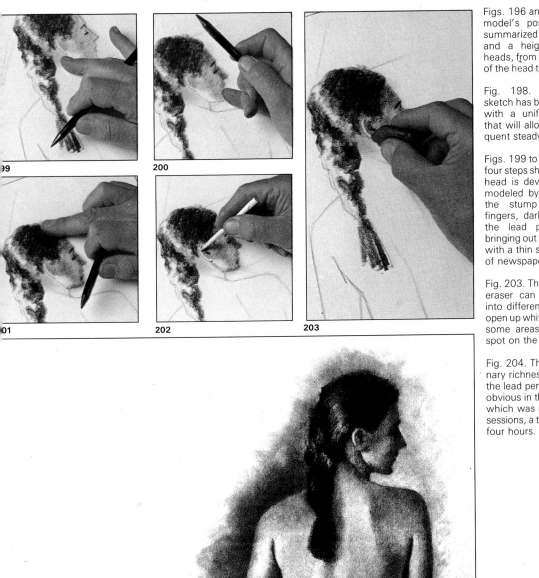

Figs. 196 and 197. The model's pose can be summarized in a triangle and a height of four heads, from the top limit of the head to the pubis.

Fig. 198. The initial sketch has been shaded with a uniform stroke that will allow a consequent steady stumping.

Figs. 199 to 202. These four steps show how the head is developed and modeled by combining the stump with the fingers, darkening with the lead pencil, and bringing out small details with a thin stump made of newspaper.

Fig. 203. The kneadable eraser can be molded into different shapes to open up whites and clear some areas, as in this spot on the neck.

Fig. 204. The extraordinary richness of shades the lead pencil allows is obvious in this drawing, which was done in two sessions, a total of about four hours.

Drawing a female nude from life

Fig. 208. Ferrón practices the old trick of measuring his model's dimensions with the pencil, using the head height to set the proportions for the rest of the body.

Figs. 209 and 210. This is the first sketch in sepia color on cream-colored paper.

Figs. 211 and 212. Now Ferrón is drawing the second sketch with sanguine color on white paper. He has finally chosen this pose for the drawing that begins on the following page.

Our guest artist, Miquel Ferrón, a fine arts teacher, is going to draw a female nude.

First, Ferrón studies the model in different poses to determine the best one. He makes two preliminary sketches, the first with sepia-colored chalk on cream-colored paper and the second with sanguine-colored chalk on white paper; both sheets measure 19¾ × 25¾ in. (50 × 65 cm). See materials in the adjacent Fig. 207. Observe in the sketches on the following page how Ferrón has begun setting the height, proportions, and dimensions of the figure by drawing a series of strokes that determine the eight-head canon. When Ferrón has already begun drawing, he checks the dimensions and proportions by means of the traditional system of measuring with a pencil at arm's length, as you can see in Fig. 208.

Figs. 205 and 206. Setting up the pose. Our guest artist, Miquel Ferrón, requested several poses from the model. He drew the sketches shown on the following page so he could decide which was the best position.

Fig. 207. The materials Miquel Ferrón used for these sketches and the final drawing include an assortment of pastel colors made by Caran d'Ache, a kneadable eraser, a rag, and a stump. Black, sepia, and sanguine are his main colors, with additions of pink, green, cobalt blue, gray, and white in some places.

First sketches

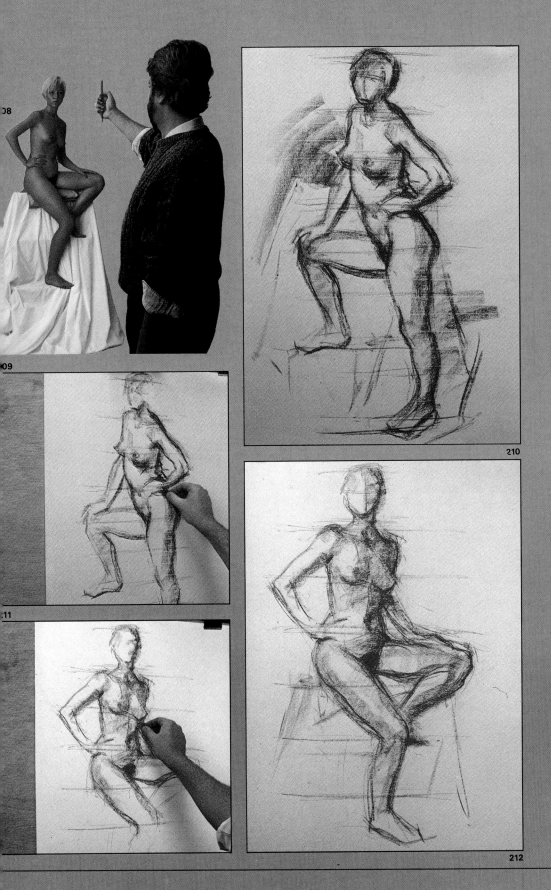

First step: The linear structure

As he begins what will be a finished drawing, Ferrón works at a distance of about 8 ft. (2.5 m) from the model. He stands at an easel with a wooden board that measures about 48 × 32 in. (120 × 80 cm). Mounted on the board is a sheet of ochre-gray Canson Mi-Teintes paper.

Ferrón measures the height and placement of the figure by relying on the eight-head canon. He begins drawing with the end of a stick of sanguine. See in Fig. 213 how he defines the shape of the head with just an oval, setting up the basic structure of the face by drawing lines to indicate the level of the eyebrows and the central axis for the rest of the features.

Ferrón uses the eraser to draw, that is, to open light areas, not to correct anything. "I forbid my students to use the eraser," he explains, "because I think the eraser is a negative element that inhibits one's efforts and ability to learn."

Finally, when he finishes the initial structure (Fig. 215), he adds: "On the other hand, errors in structure, dimensions, and proportions can be corrected as the drawing goes on, unless they are serious mistakes. In this case, the best policy is to begin drawing all over again."

213

214

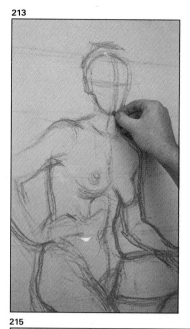

215

Figs. 213 to 216. The drawing begins with a linear sketch. Shapes and limits are corrected as the sketch progresses. In Fig. 215, the first step is complete.

216

Second step: The structure of light and shadow

Figs. 217 to 219. Next, Ferrón begins to shade the sketch. First, he indicates the shadows with sanguine color, without stumping (fig. 217), then he stumps broadly with a rag (fig. 218). The initial modeling is achieved.

To establish lights and shadows, Ferrón draws with the sanguine held flat and stumps the strokes with a rag, not worrying about the excess (Fig. 218). Then he draws in the background near the thigh with dark gray (Fig. 220), stumps the gray color, and adds pink, stressing lights and highlighted areas (Fig. 221).

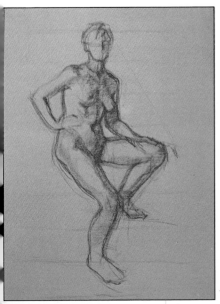

217

218

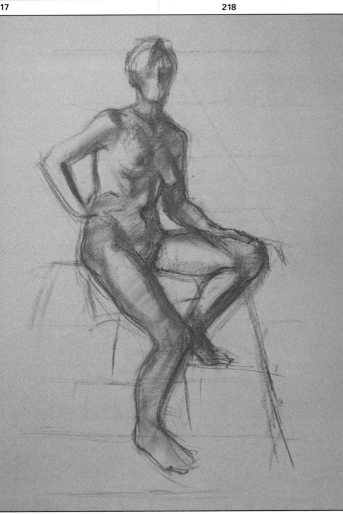

219

Figs. 220 and 221. He stains the background on the left with gray, stumps it, and adds some pink to define the model's highlights.

220

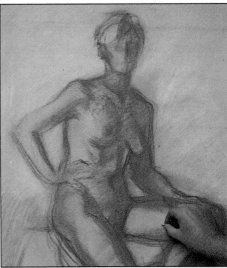

221

Third step: Drawing the body

Figs. 222 to 224. Dark sepia is used now to shade and contrast the modeling. This defines the volume of the breast, the trunk, and the arms. Black is used at the pubis, and lights are stressed with pink color.

Fig. 225. The model's trunk is almost complete after this third step. The quality of the flesh color achieved by means of a limited number of hues is quite remarkable.

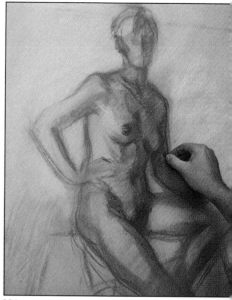

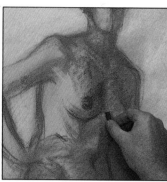

222

223

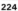

224

First, the trunk: Ferrón begins drawing with dark sepia, alternating with sanguine and pink. In some places, such as the pubis and the shadow on the left arm, he uses black. In order to define certain lights and reflections, he occasionally draws with gray, green, and blue.

Ferrón's attitude is that of complete concentration while drawing. He looks at the model, looks at the drawing, and draws. He is always looking here, there, moving his arm and his hand as if "drawing on the air," trying one stroke, testing it without actually drawing it. Suddenly, he makes a sweeping stroke on the paper. He draws quickly, stumps, combines, colors, and then pauses. He closes his eyes, leaning away from the drawing, working at arm's length, and again he approaches, defines a profile, a detail. It is all a great show.

225

Figs. 226 to 229. Ferrón stumps not just with his fingers, but with the back of his hand and a rag. Gray is added for some lights, combined with sanguine and sepia strokes. At this fourth and penultimate step, the drawing is almost finished, except for the head and some contrasts.

226 227 228

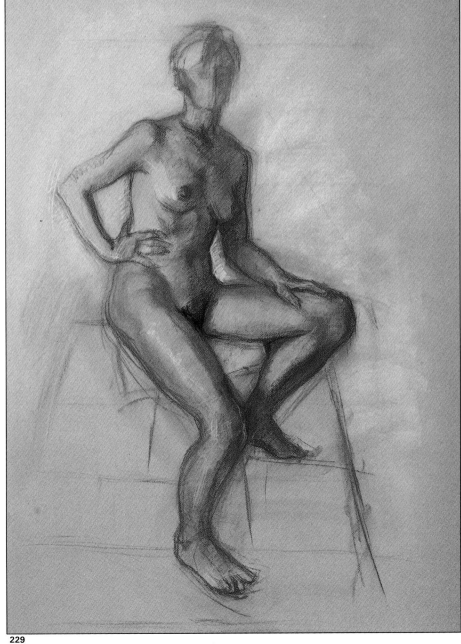

229

Last step: Drawing the head and finishing

Figs. 230 to 233. The drawing of the head is a free interpretation, with no concern for such little details as the precise stroke for the eyebrows, the eyelashes, the iris and pupil of the eyes. This approach is in accordance with the style of the rest of the drawing. No exact likeness is intended, simply an artistic rendering.

Fig. 234. The last step: highlights with white chalk on the robe where the model sits.

Fig. 235. The final outcome is a proportional, well-composed drawing. It is perfectly harmonious in color, with a wide range of shades and flesh tones created with red sanguine, sepia, and pink, as well as the cream color of the paper.

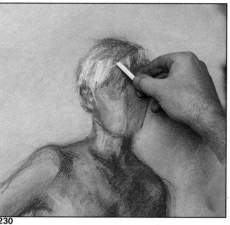
230

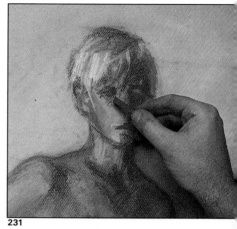
231

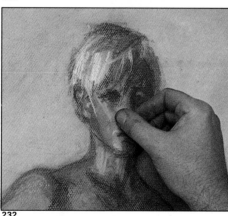
232

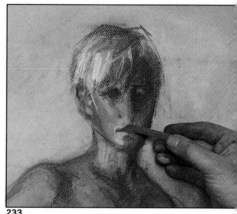
233

Ferrón colors the background behind the head with gray and violet-blue, then builds up and draws the head itself.

A drawing of the human figure is not a portrait but a study, and that includes the head. Accordingly, Ferrón establishes the appropriate shape, volume, and color, but does not worry about likeness or such details as the exact shape of the eyebrows, eyes, nose, and mouth. Otherwise the finish would not agree with the style used for the rest of the drawing.

Ferrón has achieved a finished *drawing* of the face and body, rather than a portrait, in spite of the colors he has used. In order to get this effect, he has

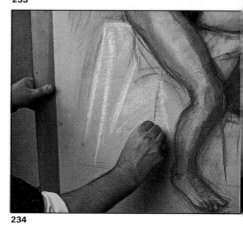
234

been drawing mostly with sanguine and sepia colors with additions of pink. He has applied the formula of the *dessin à trois crayons*, of three-color drawing.

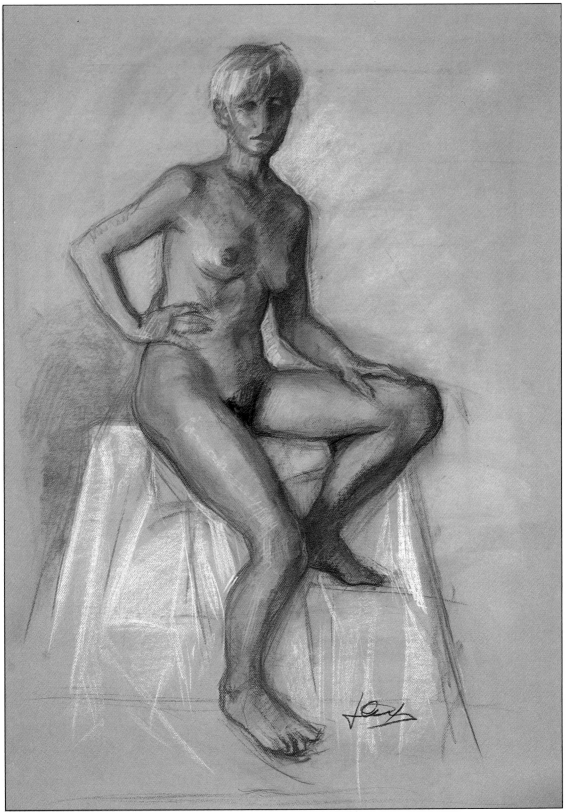

There are no geniuses by chance

Whether you know how to draw the human figure from memory or from life, or not at all, is something that depends just on you. It depends whether you are willing to work for hours until you master the subject, or not. In this matter, as in many other aspects of life, chance has no opportunity: "The chance of being born an artist" may be said, but never occurs.

You'll find your chance in the ability that all famous men have: *will and perseverance in study and at work*. Let me explain to you an anecdote concerning the will to work.

In a New York park, two old men were discussing the influence of chance in their lives. One of them stated he had had no chances, while the other confessed he felt wretched because he had wasted his youth. At that moment, multi-millionaire Henry Ford came along.

"Do you see?" one old man said. "This is a man with chances. Everything was great from the very beginning."

"Yes," the other man answered. "Everything was great for him. He had *the chance of knowing how to spend sixteen hours a day studying and working, for thirty years*."